SHABBY CHIC
The Gift of Giving

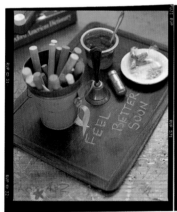 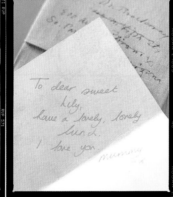 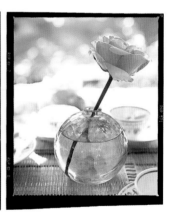

SHABBY CHIC
The Gift of Giving

Rachel Ashwell

Photographs by Amy Neunsinger

ReganBooks

An Imprint of HarperCollinsPublishers

HarperCollins books may be purchased for educational, business, or sales promotional use. For information please write: Special Markets Department, HarperCollins Publishers Inc., 10 East 53rd Street, New York, NY 10022.

FIRST EDITION

Designed by Laura Shanahan and Megan Fletcher
Text by Michelle Reo Regan

Printed on acid-free paper

Library of Congress Cataloging-in-Publication Data
Ashwell, Rachel.
Shabby chic: the gift of giving / Rachel Ashwell; photography by Amy Neunsinger;
sketches and illustrations by Deborah Greenfield.—1st ed.
 p. cm.
ISBN 0-06-039401-3
1. Shopping. 2. Gifts. 3. Gift wraps. 4. Secondhand trade. I. Title.
TX335 .A82 2001
640'.73—dc21

2001031840

01 02 03 04 05 ❖/TOP 10 9 8 7 6 5 4 3 2 1

For Lily and Jake

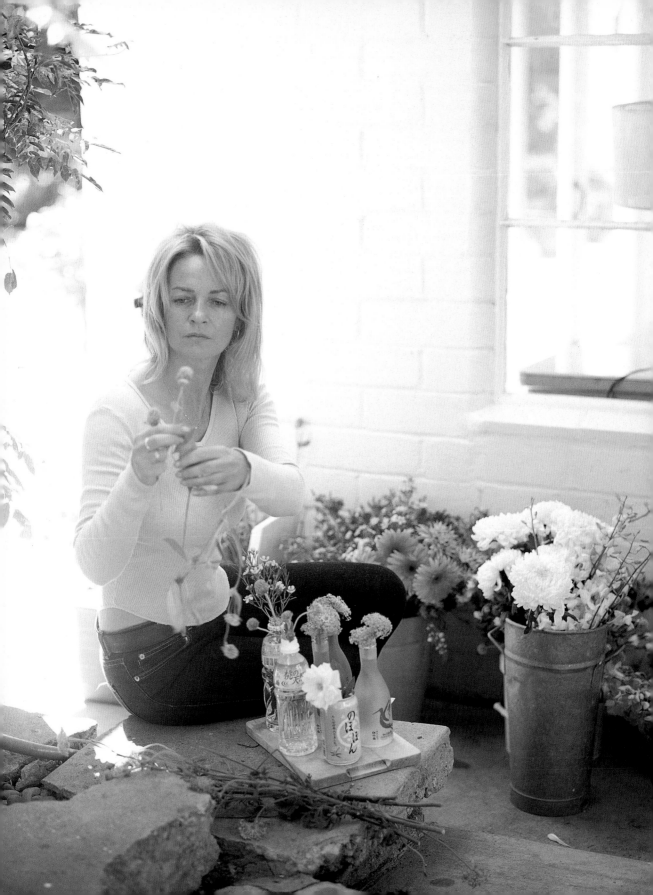

Contents

Acknowledgments

As I compiled the content of this book it became apparent that everyone involved shared a similar mind-set toward the gift of giving, which was that while friendship is the biggest possible gift, it is also important to express one's gratitude with simple gestures. A lot can be said with just a little.

To Amy Neunsinger and Stacey Sutherland for fun and photographs, to Michelle Reo Regan for words and wisdom, to Debra Greenfield for perfect sketches, to Annie Walberg for smiles and styling, to Laura Shanahan and Megan Fletcher for beauty in design, to Renée Iwaszkiewicz and Lupe Cruz for everything else, and to Judith Regan for loving Shabby Chic, simply I say thank you.

To Amy

YOU'RE THE
FINEST OF
THE FINE,

Take this little thought from me,
You are what I'd like to be.
All the kindly deeds you do,
Make me wish that I were you.
You're the finest of the fine,
Good, old loyal friend of mine.

Edgar A. Guest

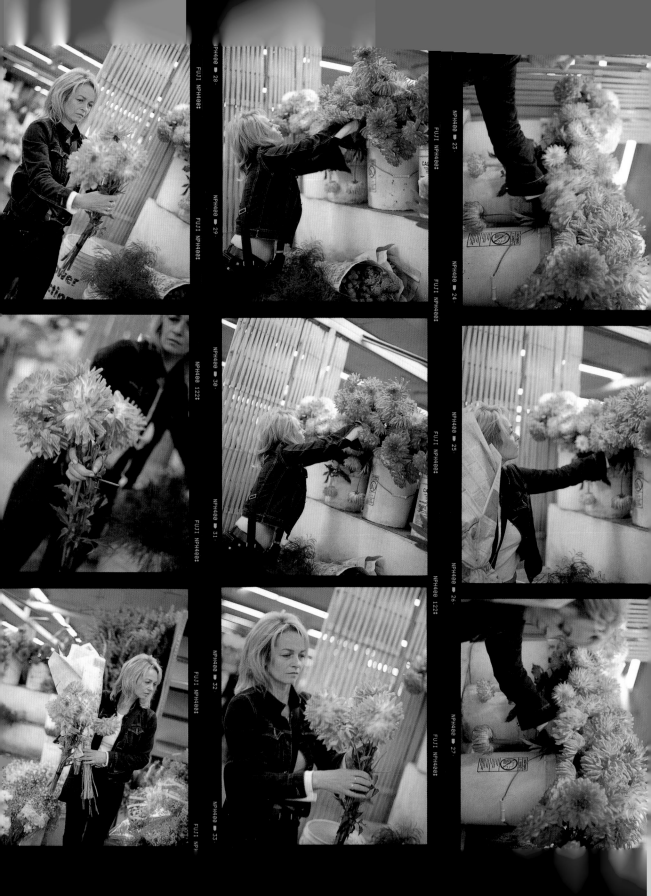

Introduction

The Shabby Chic ideals of beauty, comfort, and function apply as perfectly to gift giving as they do to furnishing a house or decorating a room. Gathering gifts, giving gifts, and receiving gifts are ways to show we care about friends, family, and people we love. I think what's really important is to pay attention and take the time to give appropriate gifts with a great deal of thought put into them. For me, the process of gathering, putting together, and presenting gifts is really a personal experience, both in what's being given and what's being received.

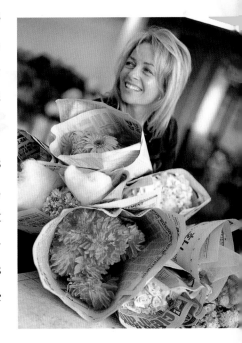

Too often today, the meaning behind gift giving is overlooked. Gift giving has become an act of duty, unnecessarily expensive, and commercial. Any gift worth giving is worth creating with effort and meaning. With that in mind, the giving of gifts becomes meaningful to the people involved—the giver and the receiver. That's what the art of giving gifts is to me.

beauty, comfort, function

Even the simplest of gestures can be made special and intimate. Recently a neighbor of mine moved away, and I wanted to relay the message, "I'll miss you, and here's a little bit of Malibu to take with you." I gathered some sand and tiny shells from the local beach, and put them into a simple antique mustard jar. The individual items were of little financial value, but the combination of the two elements—the sentiment and my effort—gave the gift emotional value.

For me, the way to achieve these kinds of gestures is to spend time in thought. Every day I keep an open mind and heart about things that might be part of a perfect gift for somebody. Each time I find myself at a flea market or antique mall, I look for everyday vintage items that I can pair with new or other antique elements to create really dramatic, beautiful, and personal gifts. The key is letting gifts evolve over time.

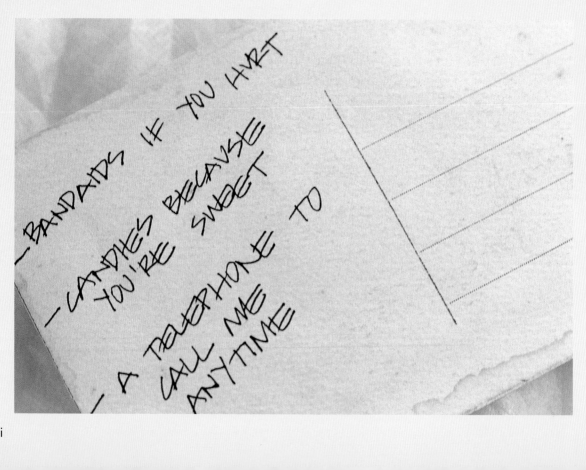

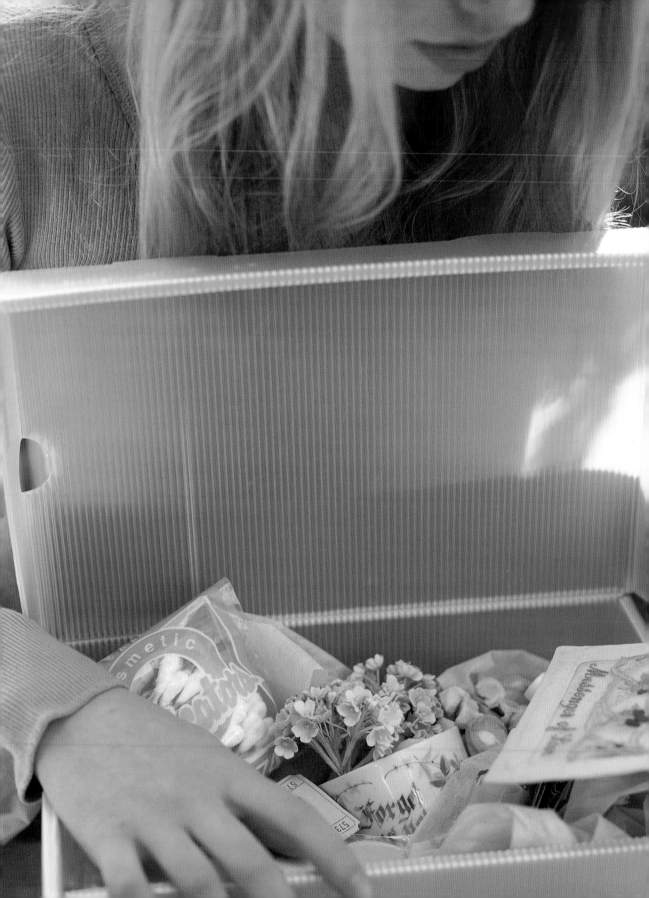

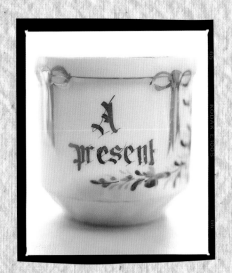

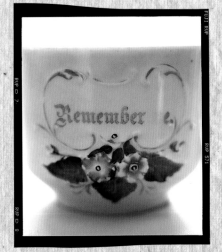

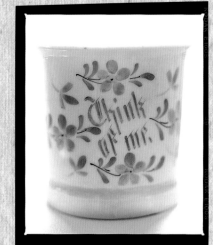

personal gifts

When vintage shopping, I never really know what I'm going to find, so it is important to keep an open mind but also to be very selective. I look for items that really speak to me aesthetically, inspirationally, or emotionally. When I find them, I put them away until the perfect occasion presents itself. The wonderful thing about shopping for gifts in this manner is that gathering is never a chore. It's never a trudge to a department store or a last-minute scramble at a mall. As well as being quite pleasurable, shopping over time tends to be cost-effective as well.

In my world, gifts do not always have to be something you can see and touch. They can be a gesture or a thoughtful effort. A simple tray of food can be a wonderful way to tell someone you care. I bring my daughter a tray every evening before bed. I give her a cup of tea or a glass of milk and some cookies. I always use a china cup and saucer, a pretty old plate, and a linen napkin. I include a little note with a couple of words to wrap up some experience of the day. Maybe she has gotten a great grade on a project for school or perhaps we didn't get on so well, but whatever the day has been like, I like to jot down a few little words. I know these notes mean a great deal to her. In fact, she has an incredible filing system for them: she puts them inside a stuffed animal that she keeps on her bed. That tattered old whale probably has more of my notes than stuffing by now.

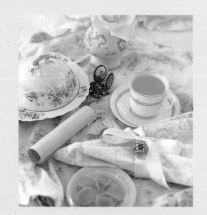

a gesture or thoughtful effort

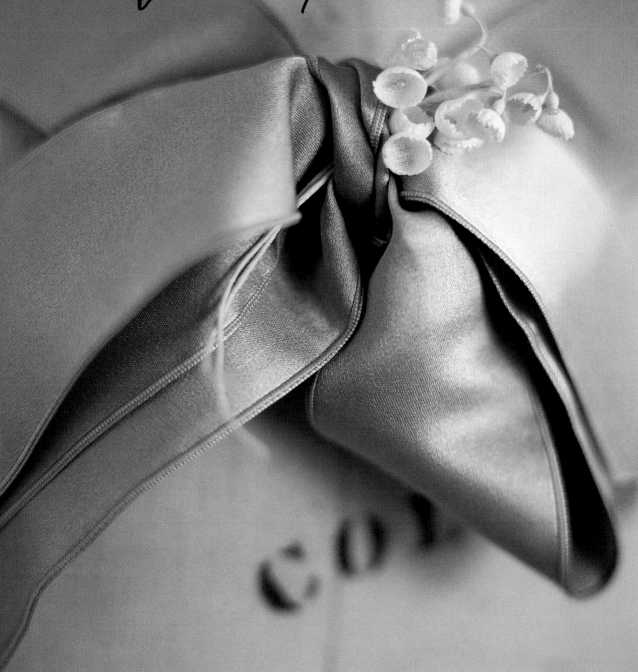

telling a story

Sometimes I like to group together a few gifts to create a story. This past Christmas, I sent my parents in London a box filled with cashmere. There were scarves, hats, gloves, and sweaters. It was obviously expensive, but I knew they would love everything. And I knew it was something they would never buy for themselves. What made it more interesting than just a sweater in a box was the luxurious abundance of the theme—cashmere—and the various elements all grouped together. Putting together a themed gift does not have to rely on expensive objects, though. My parents' gift was the exception not the rule. It's just as easy to group vases of flowers.

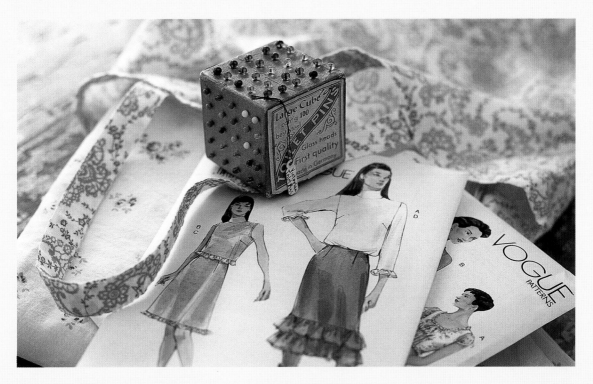

Whether it is a color, a material, or simply putting together like objects, once I find that special piece, I can then commit to a theme. This allows me to be creative and make a statement. It communicates the message, "I've thought this all through and made the effort to tell a story."

In addition to finding and putting together the perfect gift, the presentation of the gift is very important. It should be just as meaningful as the gift itself. I love to present gifts in pretty vintage boxes. Beautiful ribbons and fresh or floppy flowers are so scrummy (scrumptious + yummy). My philosophy of wrapping is that it should be an extension of the gift, and be as thoughtful as the gift. The wrappings actually can be little gifts in themselves. I always have a drawer filled with tattered flowers in muted colors and all sorts of silk, satin, and velvet ribbons.

A gift should be beautiful in itself and its presentation. The function may be specific or lie purely in its inspirational qualities. And the comfort of any gift is in knowing the affection the giver displays to the recipient through the thought, effort, and meaning of the gift.

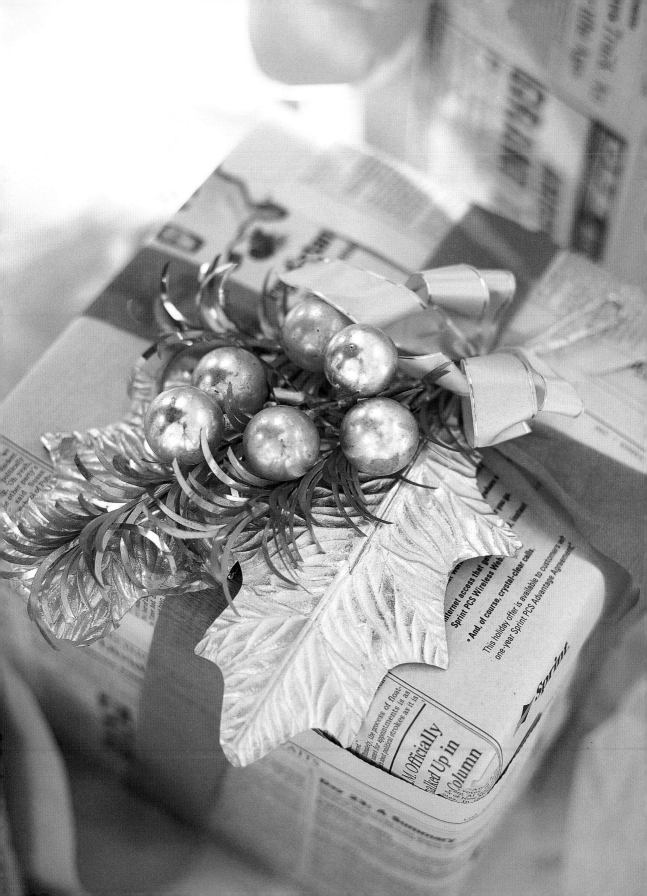

SHABBY CHIC

The Gift of Giving

Remember

Inspiratio
Philoso

al and
phical Gifts

Thoughtful tokens and gifts that motivate and inspire

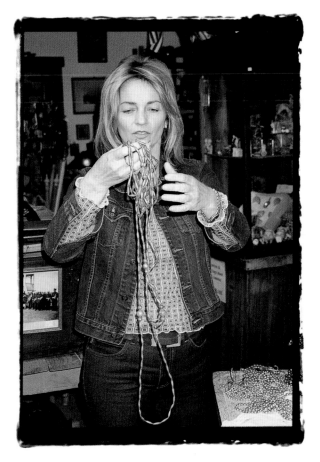

I always try to look for an inspirational quality in presents I'm gathering. When I'm creating inspirational gifts, I like to stay loyal to the core philosophy of Shabby Chic by combining the old with the new. I always seek out an object that will become the focal point of the gift, and then I add new items to make it really practical and useful in today's world.

You never know exactly what you're going to find when you're searching for gifts of this type, but if you keep your eyes open on your daily travels, you will come across something you know is absolutely perfect.

searching for treasures

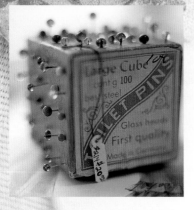

My daughter is madly into fashion. That is okay with me, providing she can be inspired creatively. Here are some pretty fabrics and a couple of sewing patterns to include in her gift.

These beautiful, glass-headed straight pins are perfect for sewing or just as something beautiful to catch the light.

Gathering Gifts

Because so many of us lead very busy lives, convenience can take over. It's so easy to just pick up the phone to order from a catalog, order on-line, or just pop over to the local shopping mall. We have all gone one of those routes at one time or another to pick up a quick gift. But, if it's at all possible, I prefer gathering gifts in my own way, over time at flea markets and antique malls. I love the idea of building and then giving a gift that will inspire somebody. This is not something you can do with a last-minute telephone call or shopping expedition. It only takes a little bit of thought, effort, and creativity.

The lovely thing about giving somebody a gift of inspiration is it really can be life changing. Therefore, the gift goes on forever. Every time the person gets involved in the particular thing that you've inspired them to do, they may remember that they were motivated to become involved in the first place because of you.

A beautiful ribbon tied in a floppy bow and a few vintage flowers were all the gift wrapping it needed.

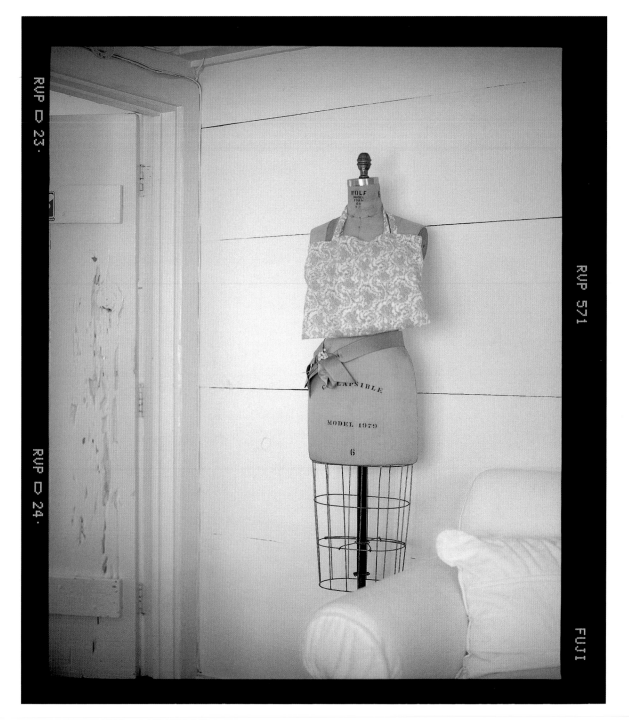

When I saw one of these dressmaker's forms at a flea market, I thought it might be a nice core for a gift to help her understand the process of dressmaking, whether sewing or designing. Attempting to wrap such an awkward gift would be too difficult and unnecessary. I placed all the smaller elements in a bag, which can be used as a sewing bag, and draped it over the neck of the form.

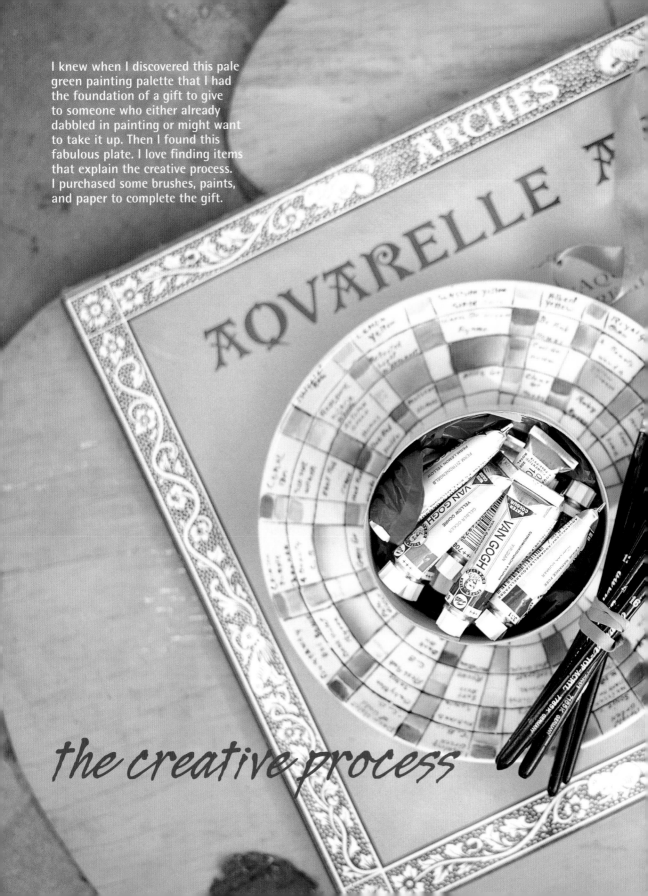

I knew when I discovered this pale green painting palette that I had the foundation of a gift to give to someone who either already dabbled in painting or might want to take it up. Then I found this fabulous plate. I love finding items that explain the creative process. I purchased some brushes, paints, and paper to complete the gift.

the creative process

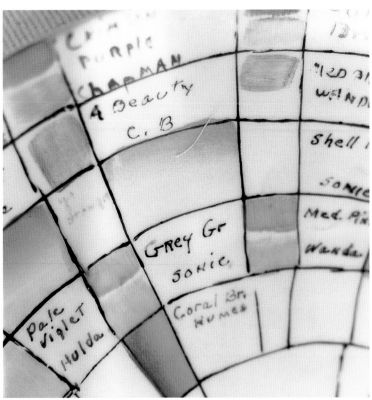

This plate shows the different shades that colors become on china after they've been fired in a kiln.

I came across two real treasures recently for someone who likes to paint. First, I spied a fabulous, dusty old painter's palette. Then, I found a plate that had been used by a factory to test the firing of colors. I love the education process that the plate demonstrates. To complete the gift, I added some new brushes, water-colors, and paper. This gift includes everything a person needs to actually paint, and then some inspiration to start them on their way.

Salt of the Earth

Sometimes people cross our paths who have a profound or very meaningful effect on our lives. For those people, I always keep my eyes open for the perfect gift that expresses my sentiments. It can be the simplest of things. It's a matter of applying thoughts and words.

Life is precious

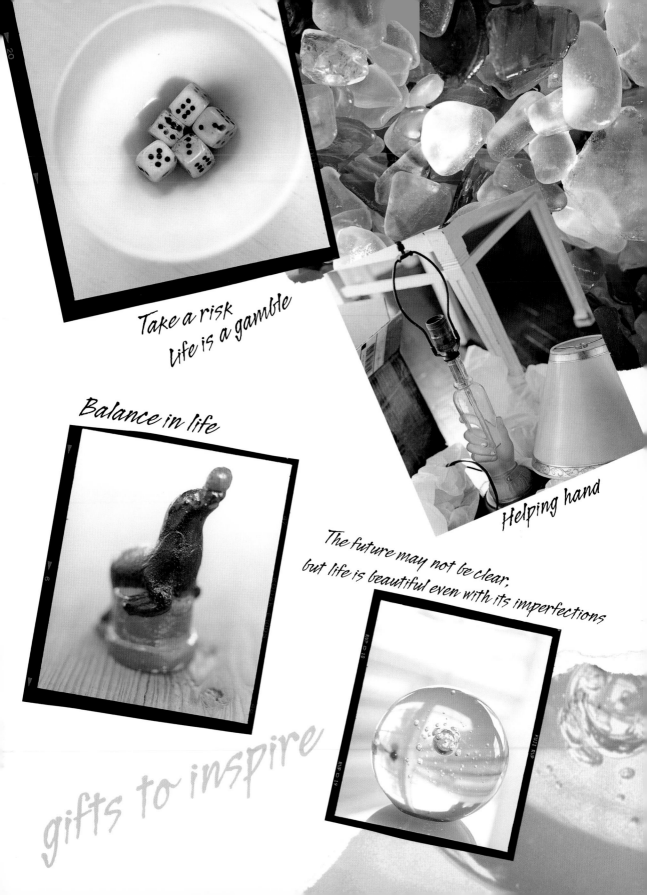

Take a risk
Life is a gamble

Balance in life

Helping hand

The future may not be clear,
but life is beautiful even with its imperfections

gifts to inspire

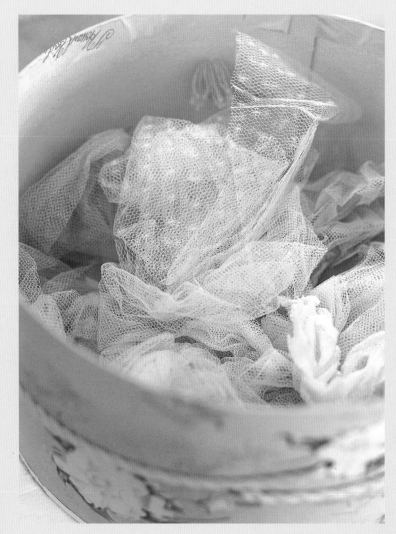

Completing the gift with
embroidery threads, a sweet old
needlepoint cushion, and new
needles and scissors leaves
no excuse for not finishing.

Presenting the gift nestled
in soft tulle in an old hatbox
creates a safe and dreamy
place for storage.

One way to present a gift of inspiration is to look for incomplete items. These are projects that people once started, but for whatever reasons they just stopped, and somehow these unfinished items land up for sale somewhere. Finding a hand-worked, incomplete item is always a pleasure for me. It leaves me wondering, Why? Why did someone start a project, put so much beautiful work into it, and then abandon it? To give a gift of this nature is so nice. It can make an overwhelming idea easier, because the project is already begun.

places for peaceful hobbies

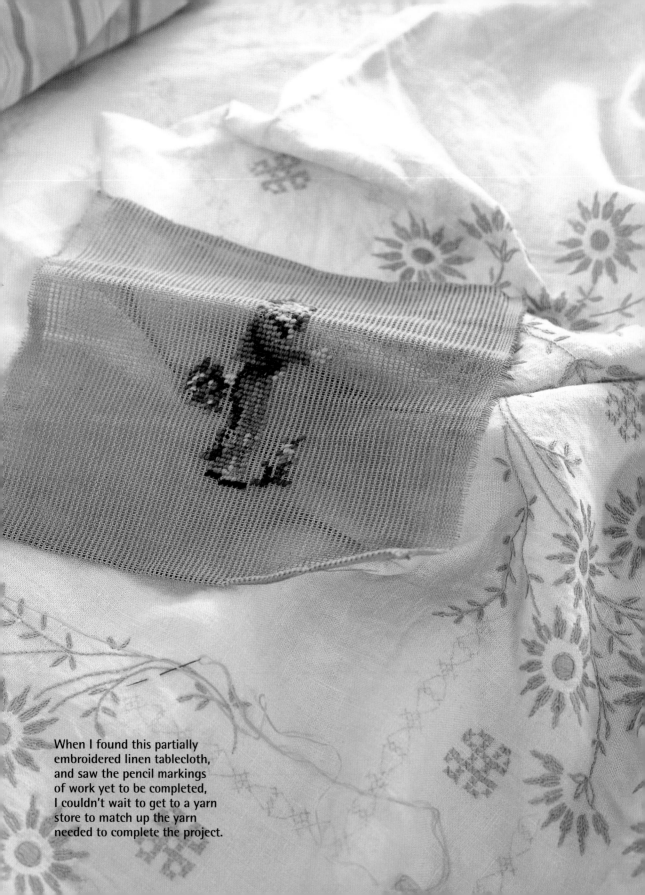

When I found this partially
embroidered linen tablecloth,
and saw the pencil markings
of work yet to be completed,
I couldn't wait to get to a yarn
store to match up the yarn
needed to complete the project.

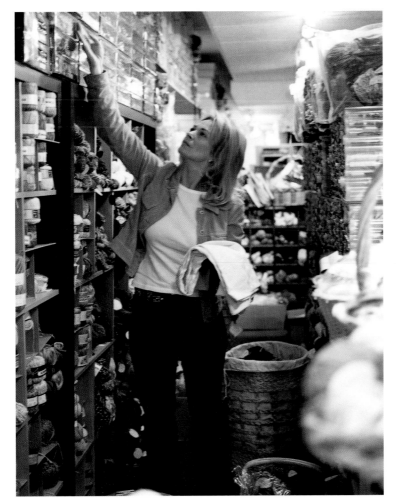

I love yarn stores. They are places of timeless hobbies, and for some reason a safe place to talk with familiar strangers or to be silent.

A while ago I came across two real gems. I found a beautiful, partially completed embroidered tablecloth and a lovely little half-done needlepoint. There was a tremendous amount of work that had already been done to both, but there had also been enough left undone that someone, if given these as a present, might find very rewarding to finish. And it's not intimidating, because the projects were already begun, and completing them isn't overwhelming. No blank canvases here to deal with. The important element to complete this type of gift would be to include any items needed to finish off the projects: in this case, some threads and needles.

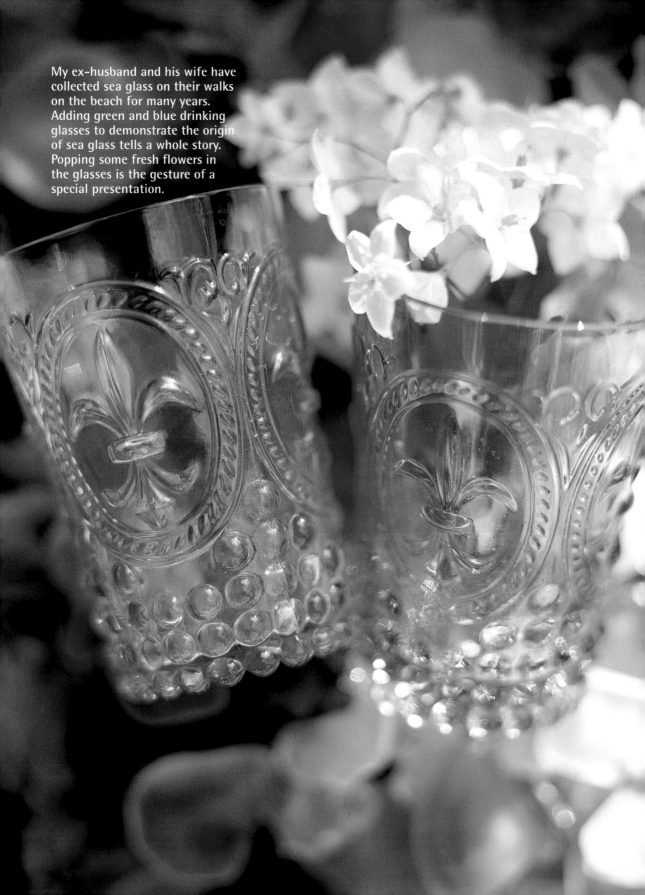

My ex–husband and his wife have
collected sea glass on their walks
on the beach for many years.
Adding green and blue drinking
glasses to demonstrate the origin
of sea glass tells a whole story.
Popping some fresh flowers in
the glasses is the gesture of a
special presentation.

Meaningful Messages

Philosophical gifts for me are similar to inspirational gifts in that they are intended to have a direct effect on a person's life. They are just simple statements, usually just one little item, that send a meaningful message. I came across a charming vintage figurine of a seal balancing a ball upon its nose. I gave it to a very good friend of mine during a demanding period in my life. The sentiment I wanted to express was gratitude for the "balance" this person had put into my life. At first glance, the seal might not be something I would have in my world, but its meaning was exactly what I wanted to say.

my inspiration

I think the enjoyment had while gathering sea glass could be applied in anyone's life. I am fortunate to live by the beach. Nothing gives me more joy than wandering around with my son, Jake, looking for sea glass, pebbles, and shells, which are a beautiful by-products of the true gift—inspiration to be out in nature. A timeless gift and a timeless act. Memories that will last forever.

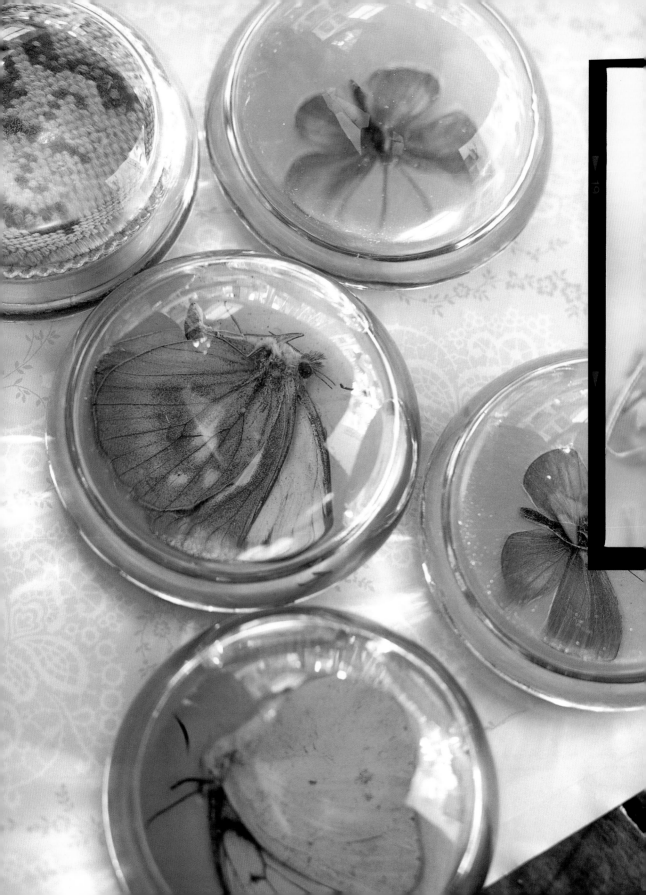

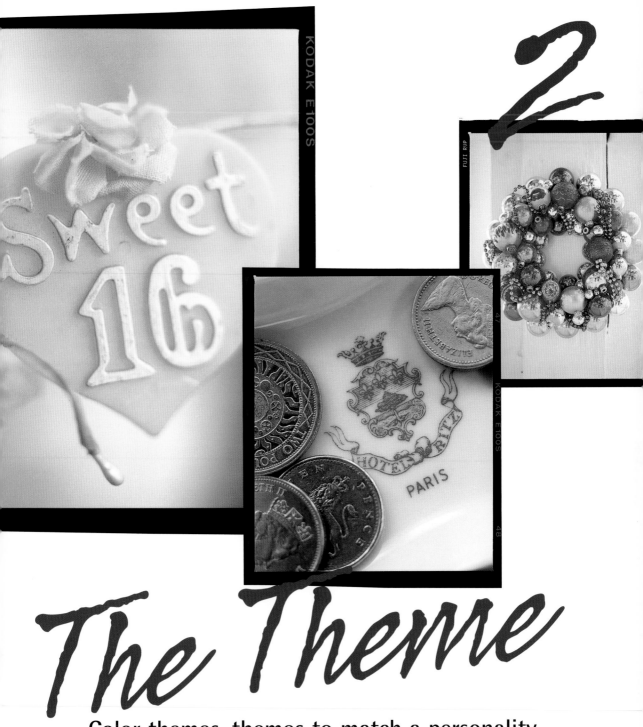

The Theme

Color themes, themes to match a personality, cultural themes, and holiday themes

My philosophy behind gathering presents that then become a themed gift is all about finding things that can be very simple and inexpensive. It's about making an individual item seem more special by grouping it together with other objects that complement one another and emphasize each one's value and meaning. It's interesting to see how individual objects relate to one another and evolve into unique gifts.

From an expense standpoint, I can make little nothings seem really big because I'm combining them with other elements. But more important, employing a theme allows me to tell a story and really make a statement with a gift. I often put together a gift based on a common physical quality such as texture or color. Sometimes I'm more literal and combine objects that share a common motif, such as butterflies or seashells.

my philosophy

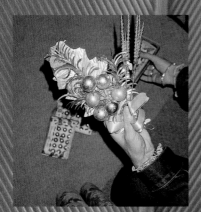

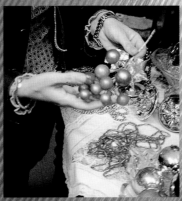

Color

Color is so much a part of my world. I love my Shabby Chic pinks and creams and greens and blues, so putting together a gift based on color comes very natural to me. When I'm shopping, no matter where I am, I seem to always be drawn to my color palette first. At flea markets and antique malls, this has led me to some wonderful discoveries. The real beauty of doing a color-themed gift is that, as long as every element will appeal to the tastes and interests of the person for whom the gift is meant, the individual items don't need to be terribly elaborate. For example, in the turquoise story that I have illustrated later, a rubber band and an antique mirror demonstrate the range and diversity in the value of the elements. It's truly more about telling a whole story than it is about spending a lot of money.

White jellybeans.

White candy...I love the tiny red accent.

A plain white box, a giant rubber band, and a tag—no frills.

Opposite: White is, of course, so simple and pure. Nothing goes together here, but the white theme is why this gift works collectively. Some white ironstone jars on an ironstone platter, a couple of white glasses, some soap and beauty products completed with a fluffy white towel make for an inexpensive but dramatic gift. It could work for a man or a woman. I think this would make a nice housewarming gift.

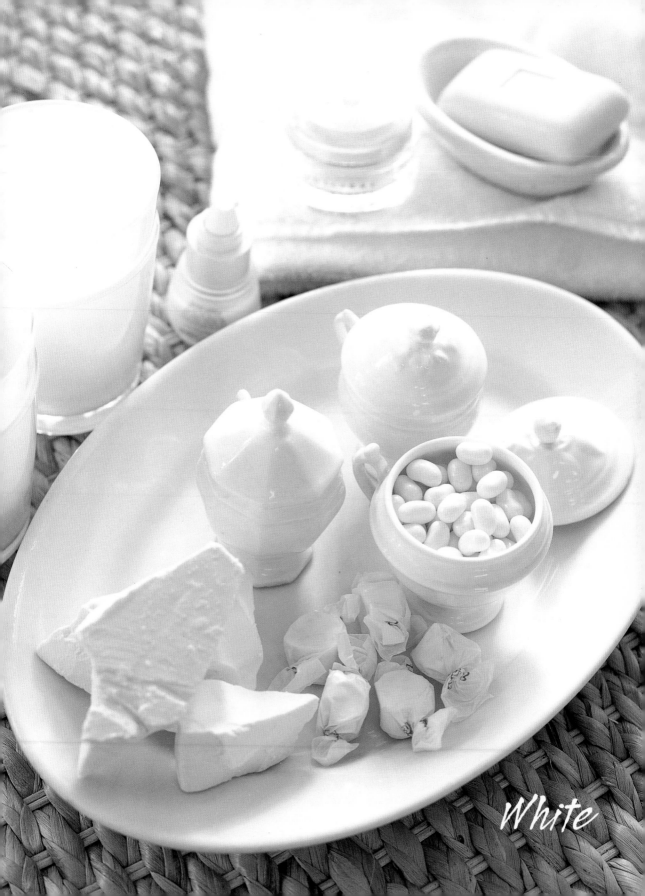

White

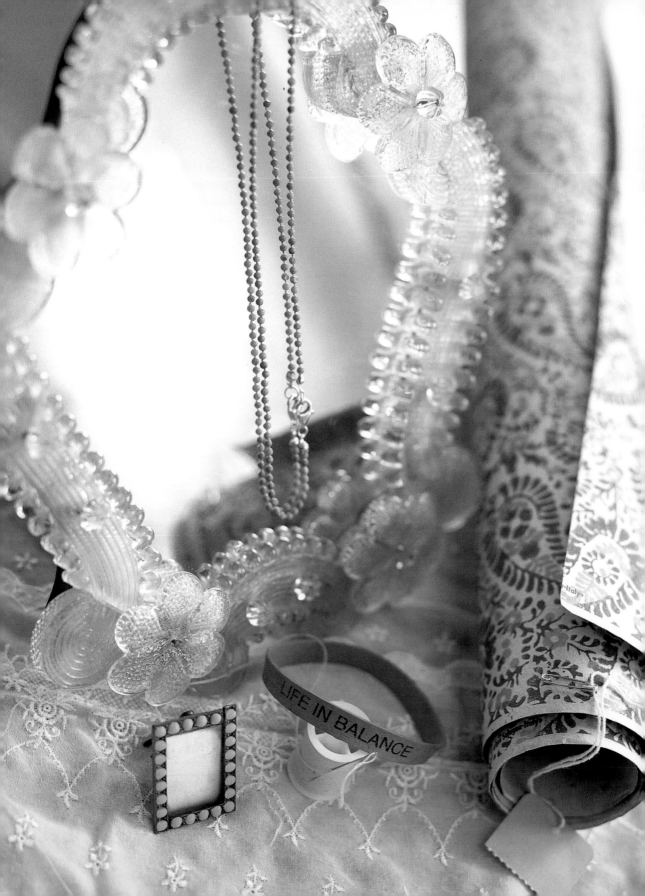

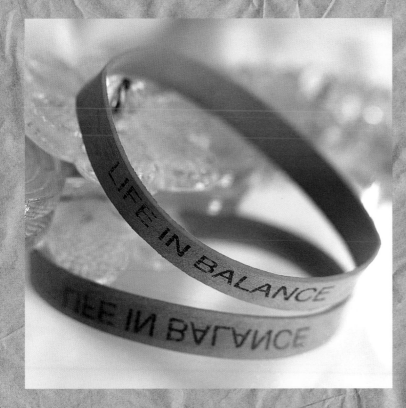

The rubber band in itself is ordinary, but the words are valuable and important to remember.

Turquoise

Opposite: Love, love, love turquoise! While the combination of all these gifts seems somewhat discombobulated, the common theme of color gives this gift order and meaning. The Italian mirror is the core gift, and perfect for any occasion: Mother's Day, a birthday, a holiday.

The whimsy of including a needle and thread is charming and always useful. It somehow grounds the theme.

I liked the mix of the hand-blocked paper and a little piece of pale blue ribbon.

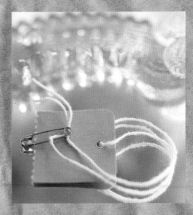

A simple turquoise label applied with a brass safety pin makes this work perfectly.

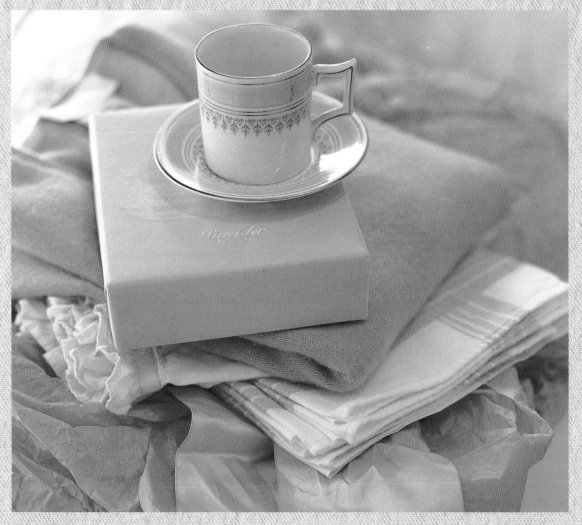

Anyone who knows me understands I would have a hard time in the world if there were no pink. I love this gift! It's perfect for any lady and occasion. The espresso cup and cashmere sweater are the main elements, but that doesn't mean the linen napkin, pink frilly cloth, and stationery are any less important. They create the attitude of the gift. Luxury, practicality, comfort, and tradition are all covered here.

While I will enjoy this stationery I was given, I will continue taking pleasure in the fabulous box in which it came long after I have used all the paper and envelopes.

Pink, pink, pink!

This silk ribbon nestled among pink tissue paper is glorious to my eyes and touch.

Because I always have an eye open for that special thing, I sometimes find treasures when I'm least expecting to. For example, I found these hand-painted shells at a tacky souvenir shop in Hawaii. Alone, they were not appealing. However, when grouped together with some beauty and function, they become priceless.

Splendid!

Along with using color as a premise for gifts, I like to create a theme by joining things with a common motif. As with inspirational gifts, this could be meant to inspire a hobby for someone or simply to make a beautiful presentation.

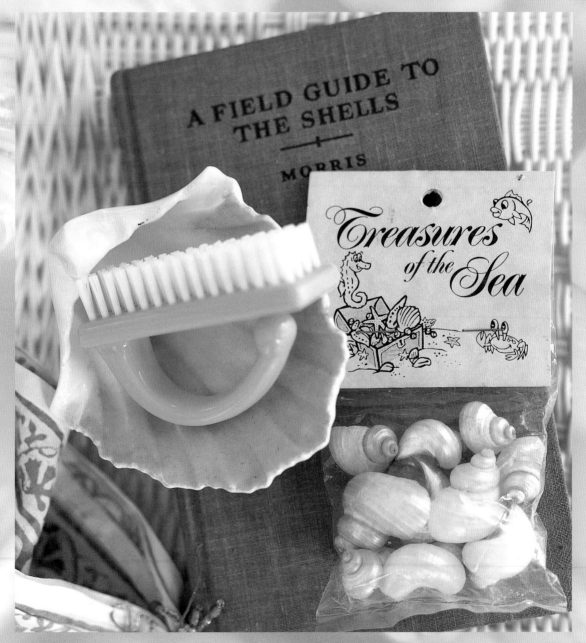

A porcelain shell dish accompanies a nailbrush. A vintage book on shells is a nice addition.

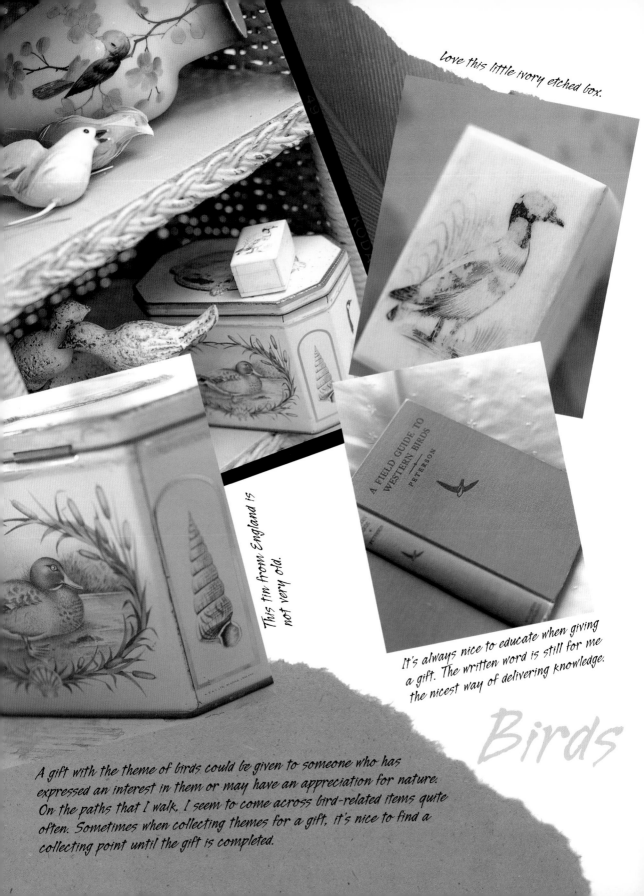

Love this little ivory etched box.

This tin from England is not very old.

A FIELD GUIDE TO WESTERN BIRDS

PETERSON

It's always nice to educate when giving a gift. The written word is still for me the nicest way of delivering knowledge.

Birds

A gift with the theme of birds could be given to someone who has expressed an interest in them or may have an appreciation for nature. On the paths that I walk, I seem to come across bird-related items quite often. Sometimes when collecting themes for a gift, it's nice to find a collecting point until the gift is completed.

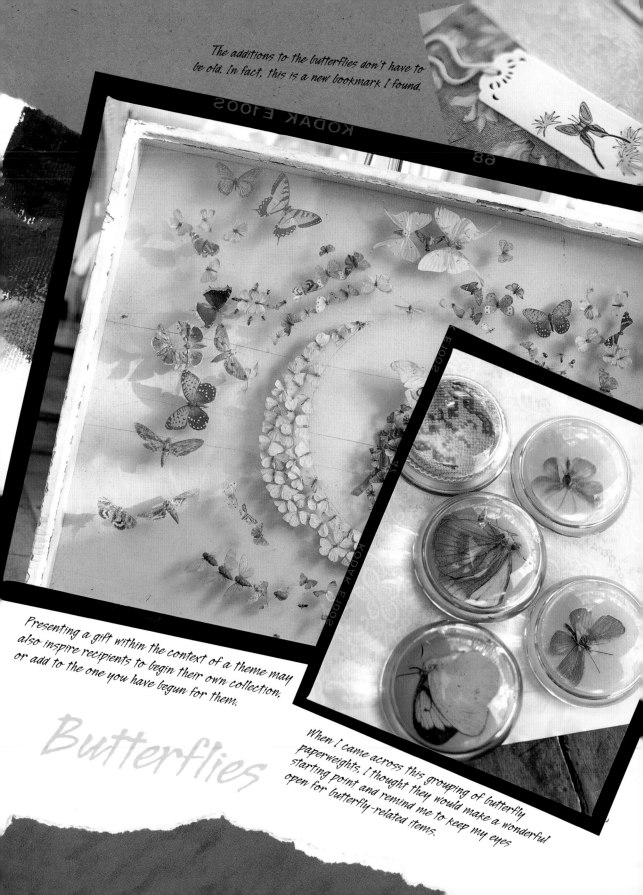

The additions to the butterflies don't have to be old. In fact, this is a new bookmark I found.

KODAK E100S

Presenting a gift within the context of a theme may also inspire recipients to begin their own collection, or add to the one you have begun for them.

Butterflies

When I came across this grouping of butterfly paperweights, I thought they would make a wonderful starting point and remind me to keep my eyes open for butterfly-related items.

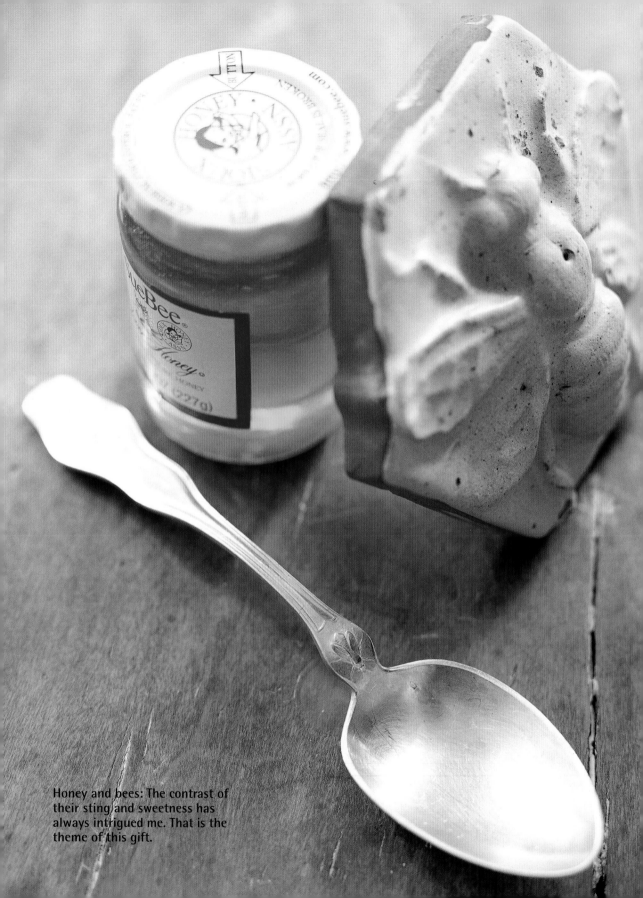

Honey and bees: The contrast of their sting and sweetness has always intrigued me. That is the theme of this gift.

Color (such as my pinks, blues, and whites) and motif (like butterflies or birds) are two very obvious ways in which to put together gifts by theme. The real challenge is to be creative in discovering not-so-obvious potential themes. I love the idea of a gift based on texture. The idea of a gift that revolves around wood is very appealing. But I could just as easily see mercury glass, linen, or even stone.

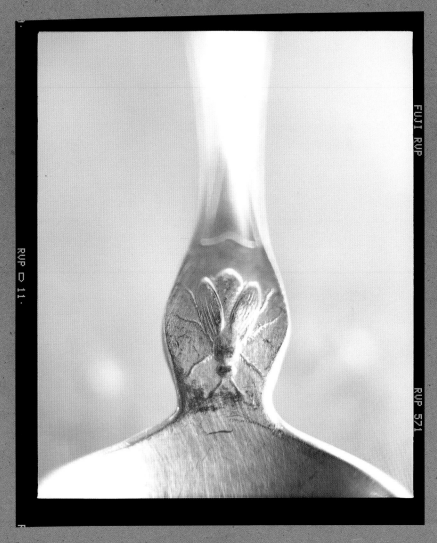

The beautiful silver spoon can rest on a pretty pale tile after it's been in the honey pot. Finito!

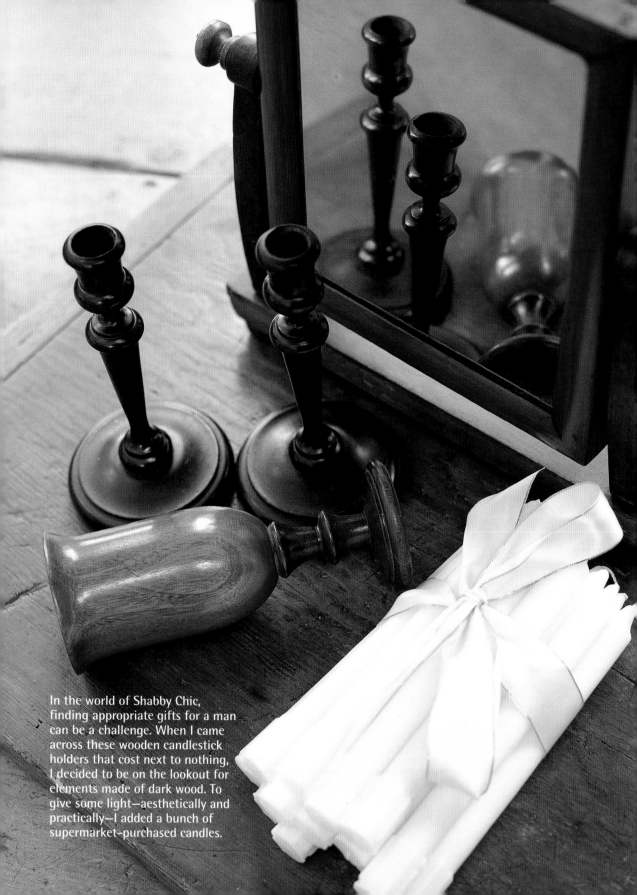

In the world of Shabby Chic, finding appropriate gifts for a man can be a challenge. When I came across these wooden candlestick holders that cost next to nothing, I decided to be on the lookout for elements made of dark wood. To give some light—aesthetically and practically—I added a bunch of supermarket-purchased candles.

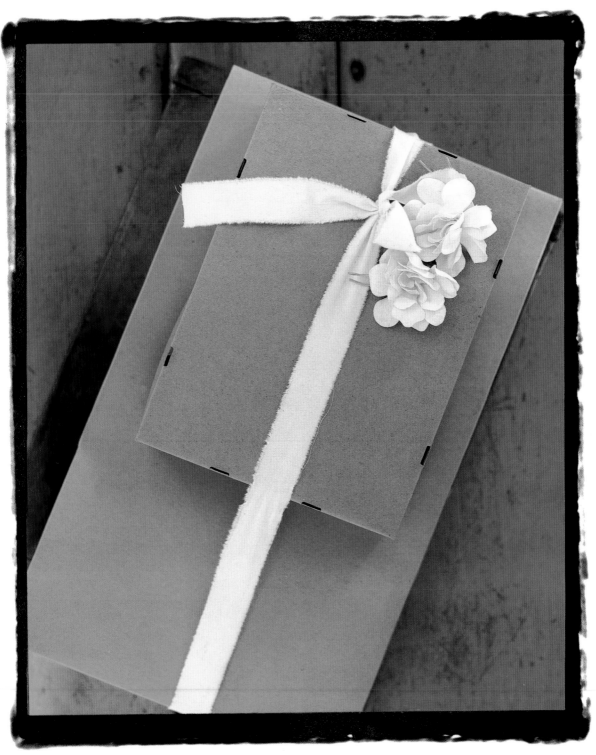

Placing all these handsome gifts inside a couple of craft boxes seemed appropriate.
I tore some fabric to create the ribbon.

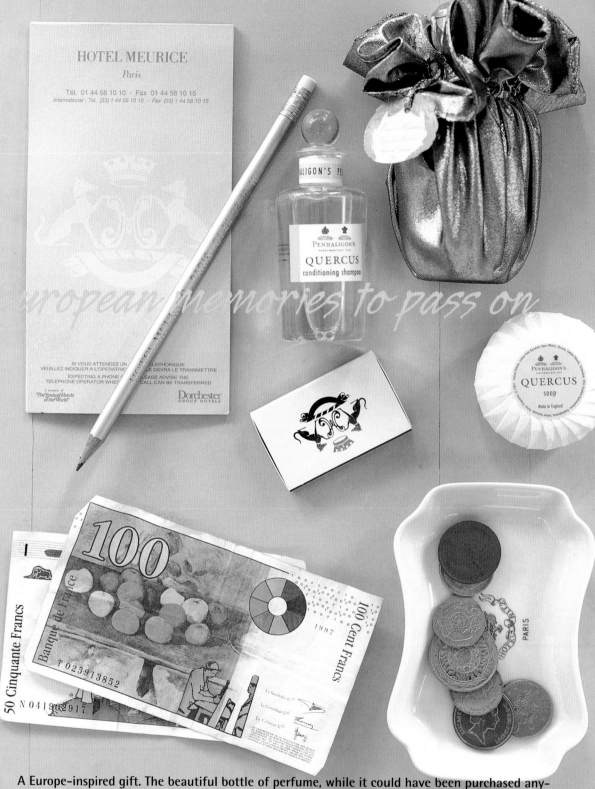

A Europe-inspired gift. The beautiful bottle of perfume, while it could have been purchased anywhere, sets the theme as French. It's supported by hotel notepaper, pencil, matches, and toiletries, which can only be found in Europe.

Culture

One of my absolute favorite ways to put together a gift of theme is by culture. This is largely about the effort of gathering. There are two ways to gather gifts by culture. The first is on actual travels and the other is by searching out local neighborhood shops.

The label on the perfume bottle is just lovely.

As small as the world is getting, with each shopping mall and Main Street from city to city and country to country looking so much alike, it takes a little more effort to give unique and innovative gifts. This especially holds true for a gift that has a true cultural feeling. However, it can be achieved by collecting items on travels you may take, domestically or abroad. Hotel giveaways and souvenir stores are great sources for additions to culturally themed gifts. As simple as matchbooks, shampoos, and napkins with hotel insignias are, they give real authenticity to a gift.

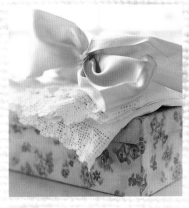

Elements of presentation that complement the contents nicely: a box from an English flea market, French wide ribbon, and Irish linen for packaging.

Some European money is always useful for a possible trip.

Gifts from different cultures are sometimes found just around the corner. I frequent this little Japanese supermarket quite regularly. I love, love, love the packaging of so many of the products: a beautiful bottle of sake, some candies, lotion, green tea, and a little tea strainer.

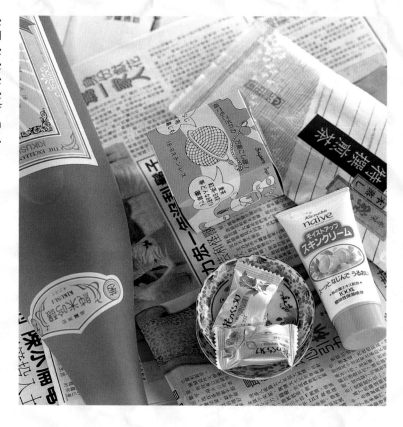

It's possible to find little neighborhood shops of one culture or another in most any city, which can make gathering a culture-themed gift pretty easy. There's a small, friendly market owned by a Japanese family not so far from my house, and I've gotten into the habit of stopping there from time to time. I love shopping there because I can find so many unique items, and because I love the cultural experience. As with flea markets, I never know exactly what I'm going to find, but I do know I'm likely to find something interesting. The family that runs the shop takes pride in their heritage. They're so eager to share their culture, and this really comes across in the atmosphere of their shop and the inventory they carry. It's often an educational experience for me.

Opposite: For this hostess gift for a dinner party, I thought it would be innovative to wrap the actual supermarket box in the store's newspaper. I used a sheet of origami paper as the gift's label, and included a miniature paper umbrella for trim. Every element of the gift's presentation stayed true to the Far East theme. Finally, I added some pastel packaging material, both for protection and because it looked pretty.

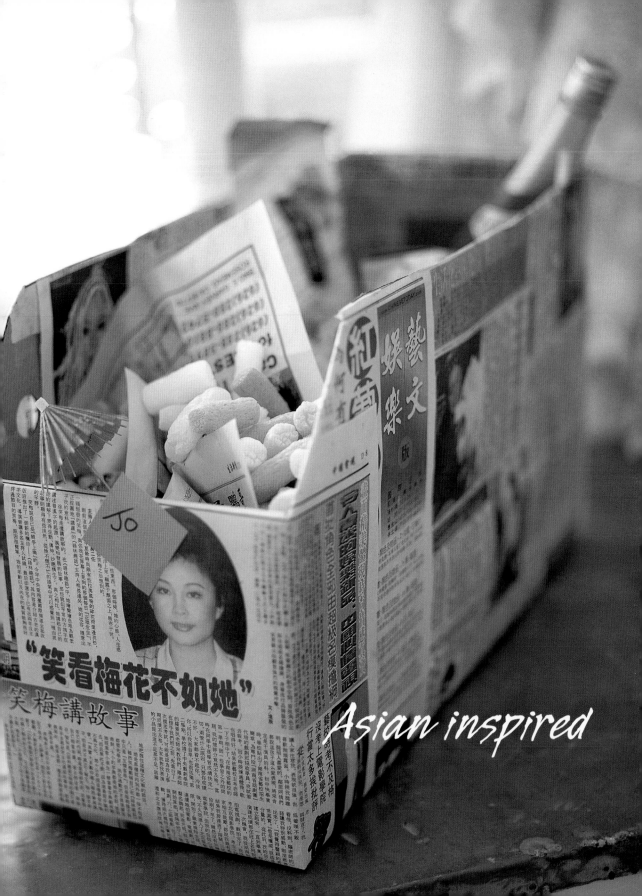

Asian inspired

EXCELLENT REFINED JAPANESE SAKE

KIKUSUI JUNMAI GINJO

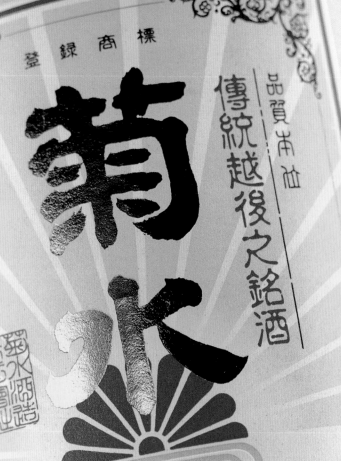

登録商標

品質本位

傳統越後之銘酒

菊水

観誉天涯

菊水酒造株式会社

清酒

菊水酒造株式会社

新潟県新発田市大字島潟七五〇

製造年月日　 12.04.14 　原材料名 米・米こうじ

As with any type of store I go to, I always prefer the humility of small, family-run shops to big, fancy stores, which tend to be impersonal, more commercial, and expensive. Shopping in quaint corner stores is usually very pleasant and friendly, as well as less expensive, and the shops somehow feel more authentic. The items I purchase tend to be common products like lotions, soaps, and candies, but because they're rooted in another culture, they seem exotic. What really makes the gifts seem substantial, even though I might only be spending a few dollars, is the common cultural theme.

Opposite: The label on this bottle is fab. Once the contents have been enjoyed, the bottle would make a perfect vase.

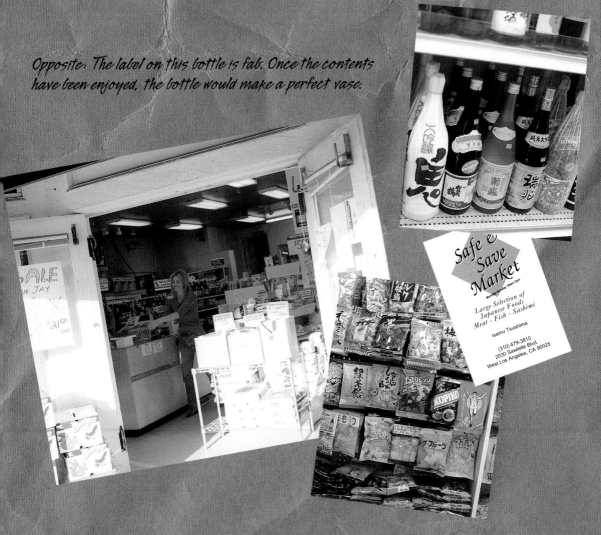

Safe &
Save
Market

Monday-Sunday 10am-7pm

Large Selection of
Japanese Foods
Meat - Fish - Sashimi

Isamu Tsushima

(310) 479-3810
2030 Sawtelle Blvd.
West Los Angeles, CA 90025

A touch of India

He's
Ros
Wate

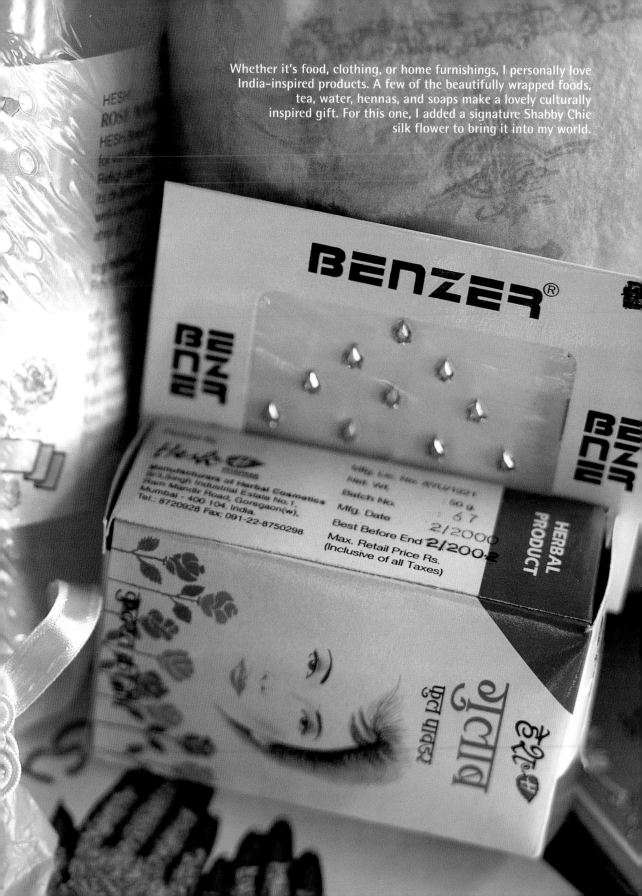

Whether it's food, clothing, or home furnishings, I personally love India-inspired products. A few of the beautifully wrapped foods, tea, water, hennas, and soaps make a lovely culturally inspired gift. For this one, I added a signature Shabby Chic silk flower to bring it into my world.

mumtaz

Al-Aroosa

حناء

دراجة أول

I have never been to India, but each time I go to my local Indian supermarket, I certainly get the Indian experience. The owners are lovely.

INDIA SWEETS & SPICES

TARUN ARORA

RAJIV KAPOOR

India Sweets & Spices

(Established since 1985)

PH. (310) 837-5286

9409 VENICE BL
CULVER CITY, CA 90230

www.indiasweetsandspices.com

This is the most beautiful statue with its unusual colors. There is something so peaceful about the very presence of this piece.

In India this lovely bracelet is worn on special occasions. Whenever I see specialty stores like this one, I always pop in for the unexpected treat for myself or to give as a gift.

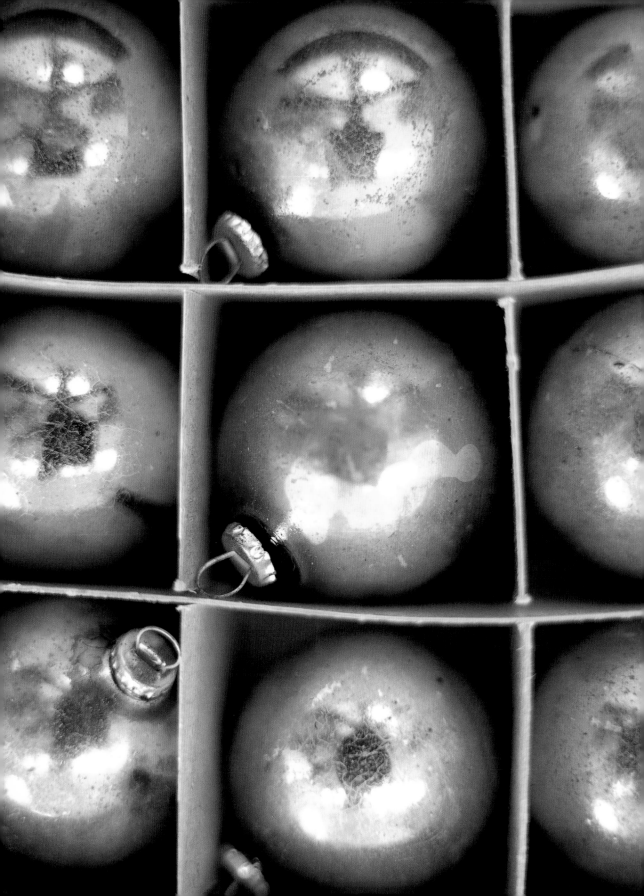

Holidays and Celebrations

Another great way to build a gift of theme is to base the gift on a holiday or an occasion. Easter is perhaps my favorite because of the colors; Easter baskets for me are quintessential Shabby Chic. I also like the idea of a gift that revolves around eggs for occasions other than Easter. They truly represent new life, new beginnings. Tying into the cycle of life, a gift with the theme of an egg might make a lovely present for expectant parents, or perhaps to someone to signify the "birth" of a new project.

I've given many gifts with a Christmas theme for that holiday, even though the traditional reds and greens associated with Christmas are not thought of as part of my palette. I do, however, adore pale pink, pale blue, pale green, silver, and gold Christmas ornaments, which are surprisingly easy to find in vintage worlds—especially off-season. As a Christmas hostess gift, I've given a simple box of these vintage ornaments.

vintage ornaments

Christmas is one of the most festive times of the year. I like to keep as traditional as I can, but if possible I always try to stay within my palette. To give a present within the theme of Christmas is quite easy. I rely on both flea markets and antique malls to find wonderful, vintage Christmas decorations, especially off-season.

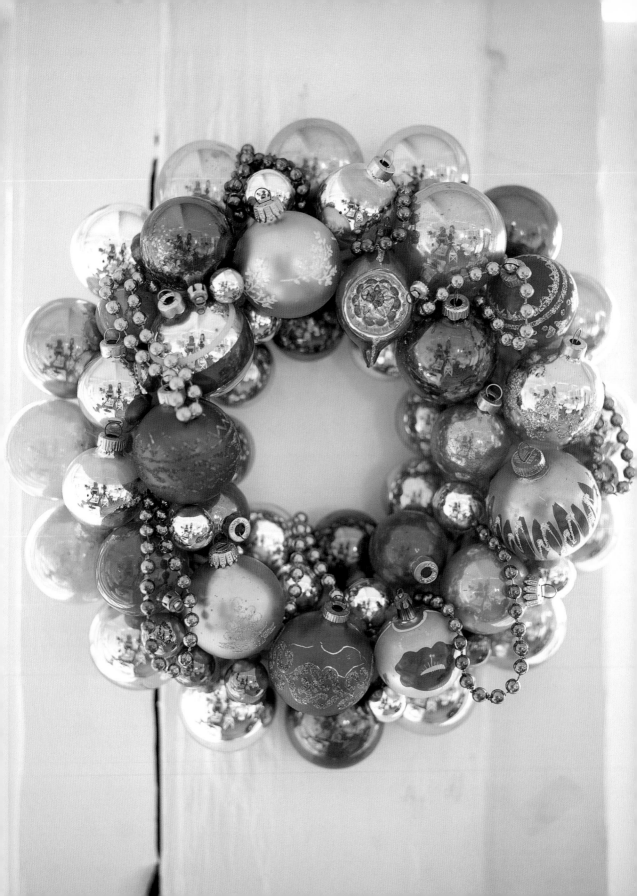

Not too long ago, I met a girl who had ingeniously made this wreath out of vintage ornaments. It's Shabby Chic at its best—twinkle, tarnish, and all.

so shabby chic

If I use these smaller decorations on a large tree,
I intermingle them with standard-size ornaments.
A collection of vintage decorations would
make a nice present.

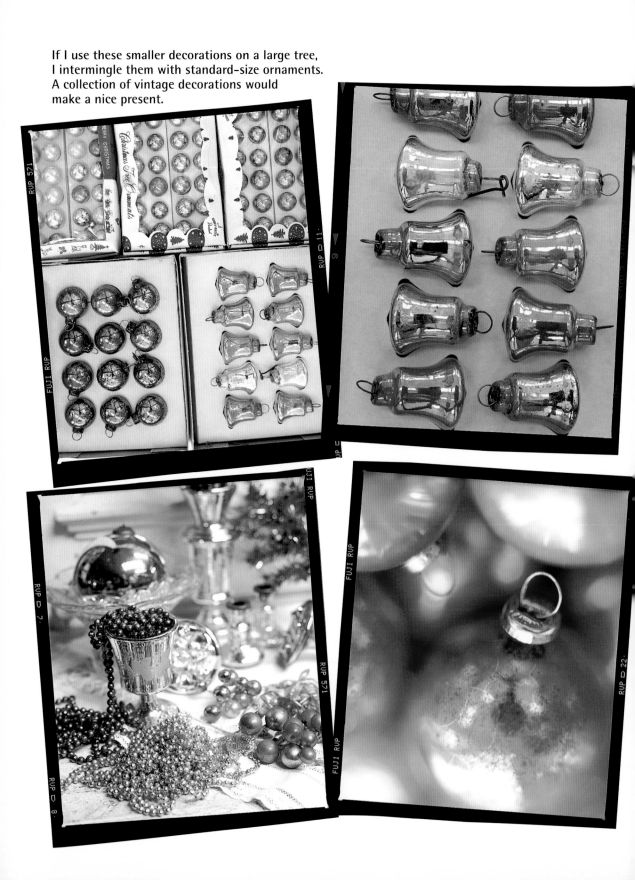

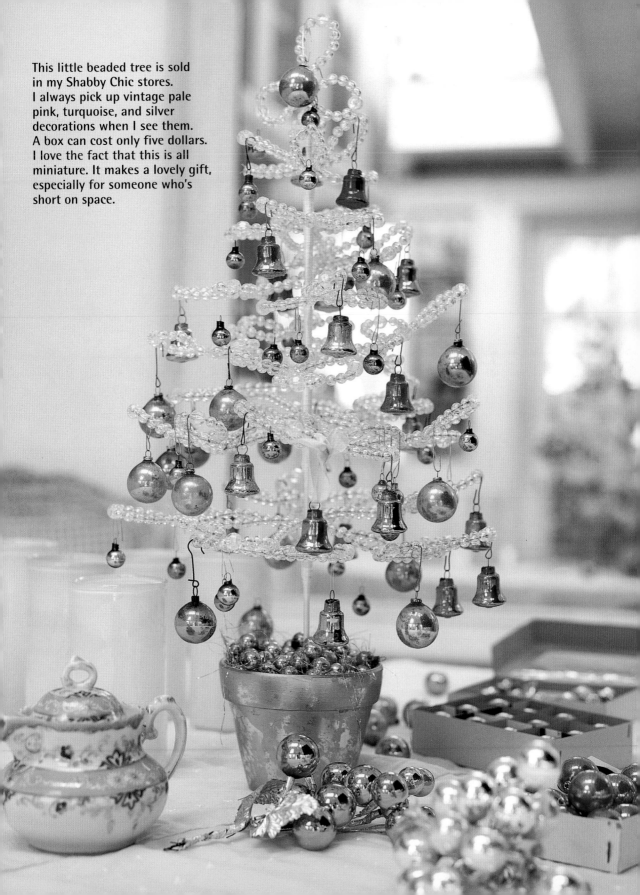

This little beaded tree is sold in my Shabby Chic stores. I always pick up vintage pale pink, turquoise, and silver decorations when I see them. A box can cost only five dollars. I love the fact that this is all miniature. It makes a lovely gift, especially for someone who's short on space.

One of a kind

Along with it being perfect for Easter, an egg-themed gift always seems relevant to life and new beginnings. Shredded paper makes a lovely nest for this fabulous egg I found at a flea market. Tucked under it are a couple more eggs I found off-season at a supermarket.

A charming old hatbox with a treat placed casually inside is a nice discovery for anyone.

Jewels and velvet bows adorn this one-of-a-kind hatbox.

This is what I consider a lovely thought for a sweet sixteen birthday. Again, it's the combination of the old and the new. The hue on this cake topper is fabulous, and the sweet sixteen heart looks like white chocolate. The little lady is perfect enough to be elegant in her pink silk dress, but tattered enough to be lovely. A tiny red wallet houses some money in an innocent way.

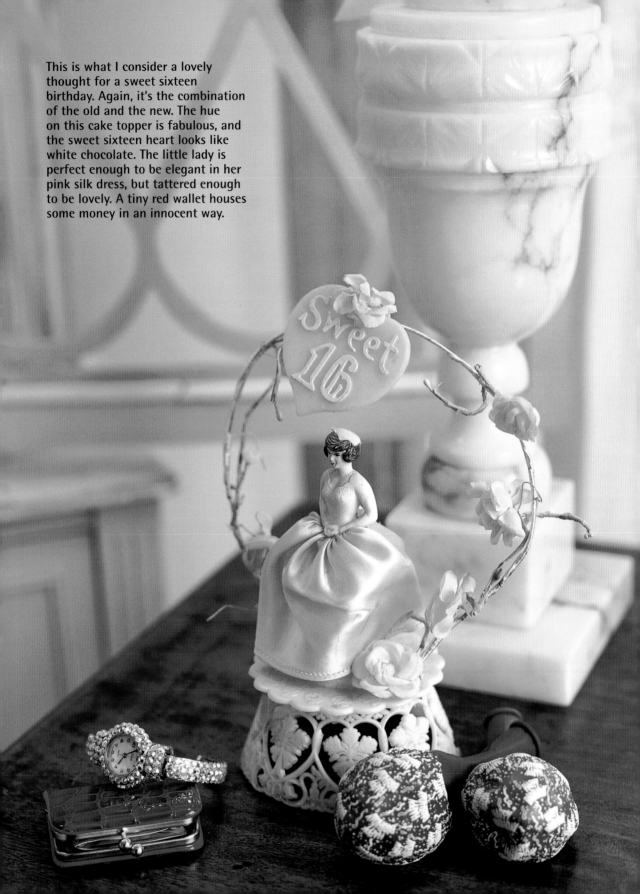

Even at sixteen, balloons are a must.

Sweet 16

This fun jeweled watch would be a joy to receive.

Paper ar

d Ribbon
resentations

Making wrappings, ribbons, and cards

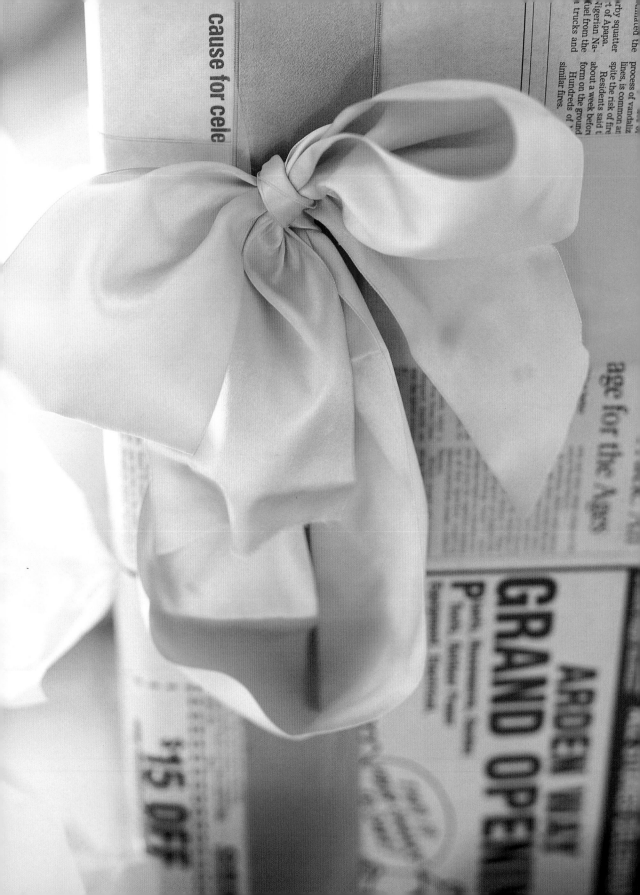

I believe that how a gift is presented is such an important aspect to the art of giving gifts. The perfect gift for someone deserves a splendid presentation. A gift's presentation should always be an extension of the gift, perhaps even a continuation of a gift's theme. It should be thoughtful and beautiful in its own right.

I go about the presenting of gifts in much the same way I put gifts together: I use a combination of contemporary and vintage items, and I try to stay true to my palette. I collect potential wrappings over time. One thing I do in addition, though, is recycle, both for the sake of our planet and to acquire a potpourri of different items and styles. I held onto a great shoe box recently. It was my color and sort of interesting in texture, so I stored it away because I knew that at some point I would put it to use. I always save pretty ribbons, too. I think a ribbon that's been used has a lovely patina to it.

simple glamour!

The first thing the recipient of a gift sees is its presentation. A card, gift tag, the wrapping, or even the tone of how the gift is accented has a great effect. Keeping my eyes open at flea markets, vintage stores, art supply shops, stationery stores, and fabric stores allows me to accumulate bits and pieces rather effortlessly over time so that I always have appropriate and lovely supplies for planned and unplanned situations. A big floppy silk bow is so glamorous and happy against this newsprint background.

My taste in supplies is very diverse. I find that pedestrian things such as packaging peanuts, newspaper, labels, and Bubble Wrap are always useful. I'm very partial to tissue paper. Vintage millinery items and hatboxes are also an important part of the process. One thing I like to do is mix the everyday with the beautiful. I love the idea of a box wrapped in plain black-and-white newspaper but tied with a wide, silky vintage ribbon in a soft color. It's a lovely contrast in color, texture, and ideas—a tattered elegance. As is always the case with Shabby Chic, I don't like the wrappings to appear perfect. I like to see a little evidence of how it's been constructed, whether that is a little visible tape or a drip of sealing wax. I think it adds character.

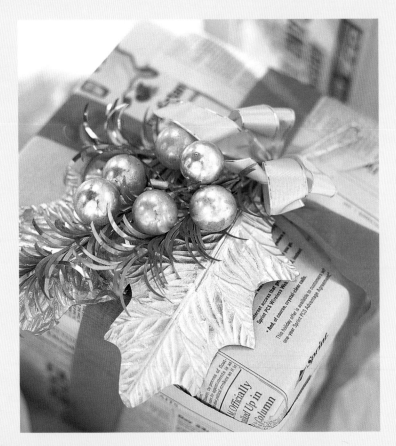

I used this mercury and foil Christmas decoration to adorn a gift. It's attached easily with basic drugstore-purchased crepe ribbon.

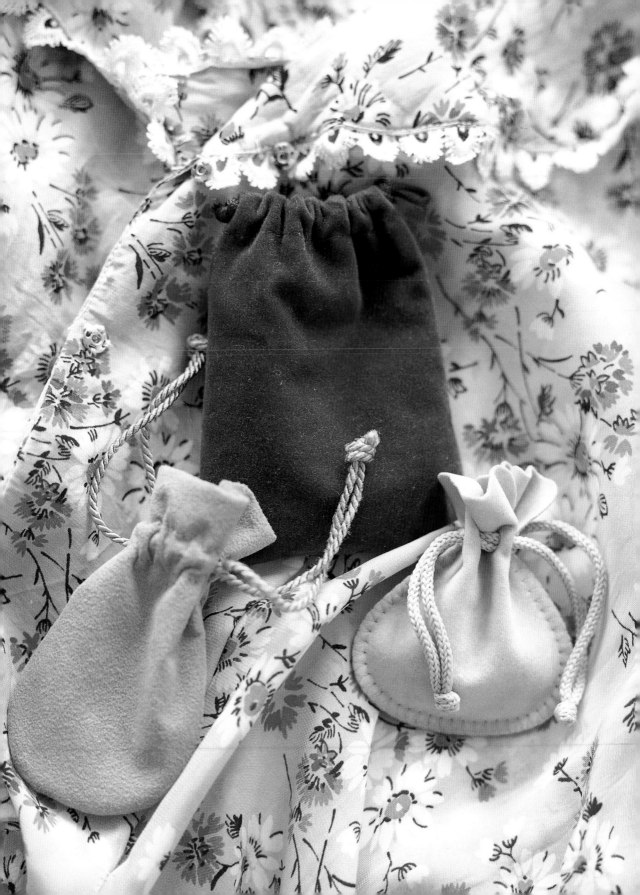

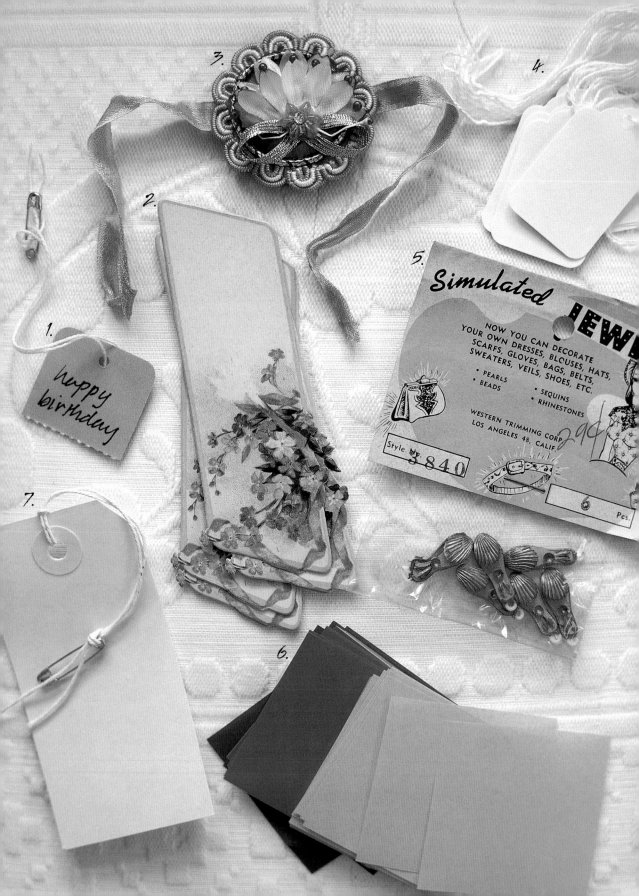

3.

4.

2.

1.

happy birthday

7.

5.

Simulated JEW

NOW YOU CAN DECORATE
YOUR OWN DRESSES, BLOUSES, HATS,
SCARFS, GLOVES, BAGS, BELTS,
SWEATERS, VEILS, SHOES, ETC.

- PEARLS
- BEADS
- SEQUINS
- RHINESTONES

WESTERN TRIMMING CORP.
LOS ANGELES 48, CALIF.

Style No. 3840

6

Pcs.

6.

Six inches of extra-wide ribbon is enough to make your own personalized envelope by sewing the edges, turning down the corners at one side, and adding a popper snap.

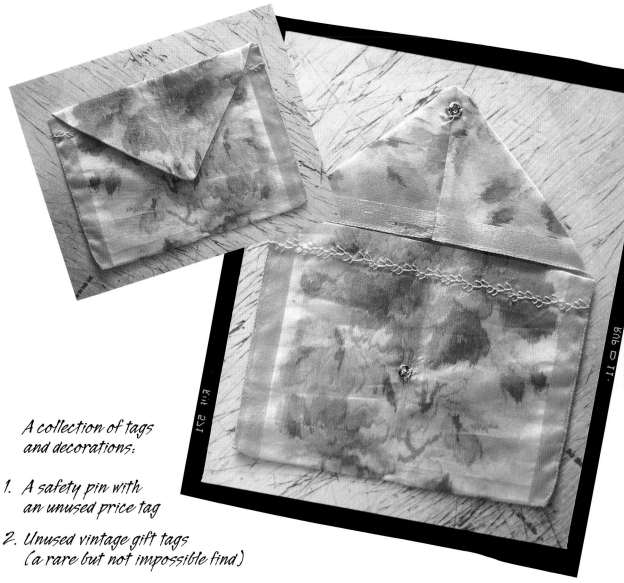

A collection of tags and decorations:

1. A safety pin with an unused price tag

2. Unused vintage gift tags (a rare but not impossible find)

3. A traditional Indian bracelet

4. Simple white tags

5. Slipper charms

6. A stack of origami paper

7. A large hang tag

Packaging

Layering is really the key to presenting gifts: First there's the actual packaging, then the wrapping adornments, and finally the gift tags and cards. Packaging materials such as Bubble Wrap or packing peanuts should be used generously when called for. It's very practical in that it serves the function of protecting the gift, but it can be used as an accent, too. It's quite a luxurious sight to see a sumptuous layer of colorful peanuts protecting some delicate china. I figure that if I'm going to work with it,

I might as well take advantage of it and make it part of the presentation visually. This is so easy to do, because it's possible today to find a whole array of different colors and textures. Check with local packaging stores or suppliers for the varieties available. You may have to buy a somewhat large quantity, but you'd be surprised how quickly you might go through supplies over the course of time.

Opposite: Packaging material can set a mood and be beautiful as well. This rainbow selection of Styrofoam would be the perfect support for any Shabby Chic gift.

I made this packaging material myself. A paper shredder and colored paper were all I needed.

recycle!

Bubble Wrap comes in many colors and sizes. I always save pieces
I've received from other gifts or purchases.

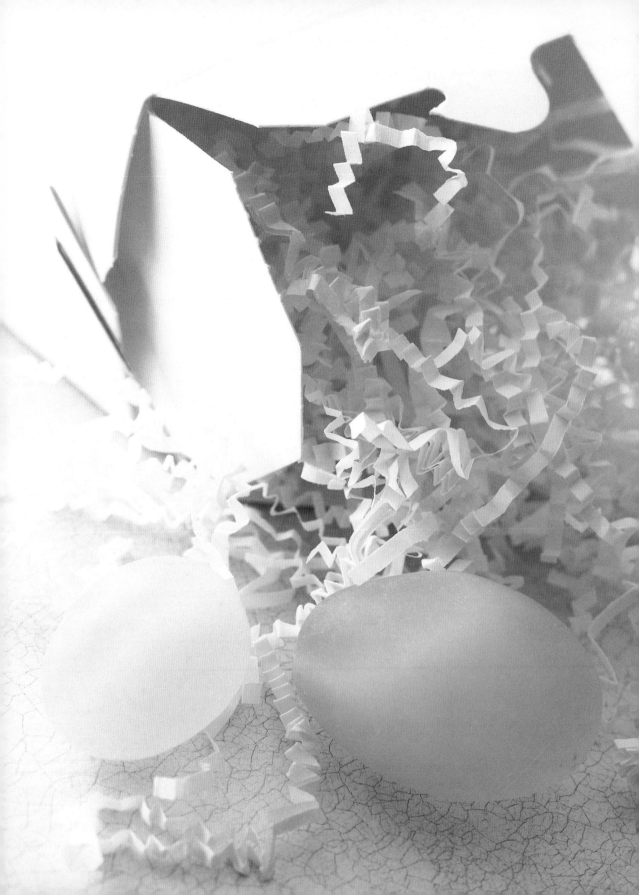

The Box

The next layer is the actual box. While I love hat-
boxes and pretty vintage boxes, I don't limit myself
to them. One thing that I find really appealing is a
standard brown box. It's so simple. And, it's a blank
palette awaiting some attractive accents. They are so
accommodating in that they can be easily acquired in
virtually any size. Sometimes a pouch serves the pur-
pose even better than a box. Other times, a gift might
not even need to be encased. This especially holds
true if the gift is large and cumbersome. When there's
no box, the presenting relies solely on the accents,
such as a beautiful hanger or a bow.

I always hang on to boxes I think can be reused. Sometimes, I buy them on my travels.

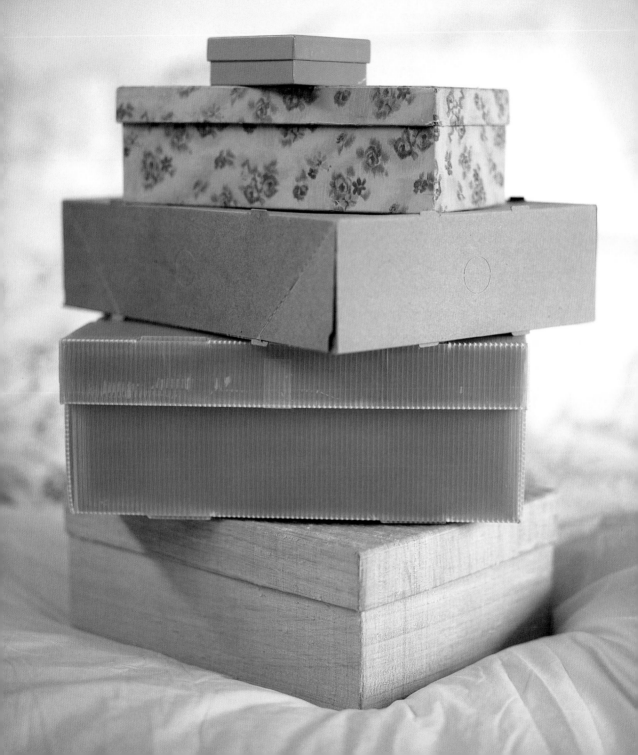

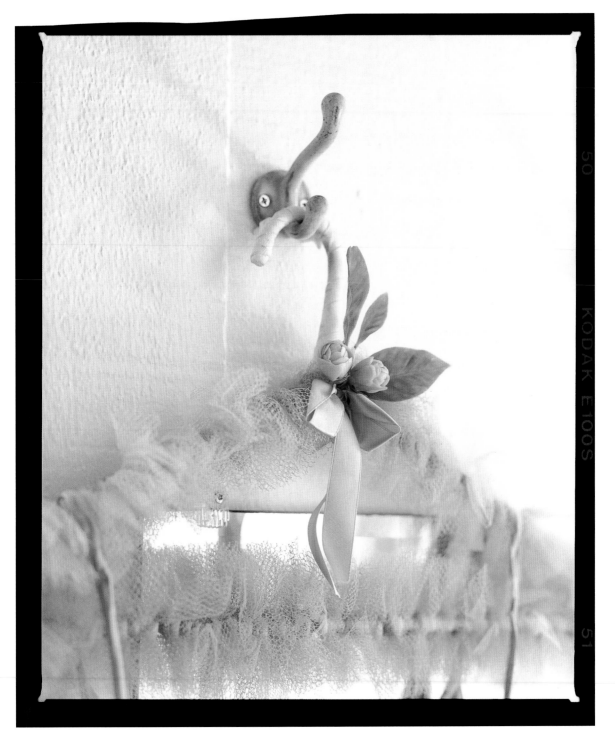

While this tulle-covered hanger is totally over-the-top, it creates a platform for a basic dress. No wrapping needed.

Not every gift has to be wrapped to be presented. It is important to think about the best way something can be used and enjoyed—beauty and function. Receiving clothing is always nice, but adding a special hanger is a way of bringing your own personal touch to a gift. I found a set of six of these green velvet hangers. The little beat-up ribbon is perfect.

A chunky wooden hanger with a feminine pink note is the perfect way to present such a girly camisole.

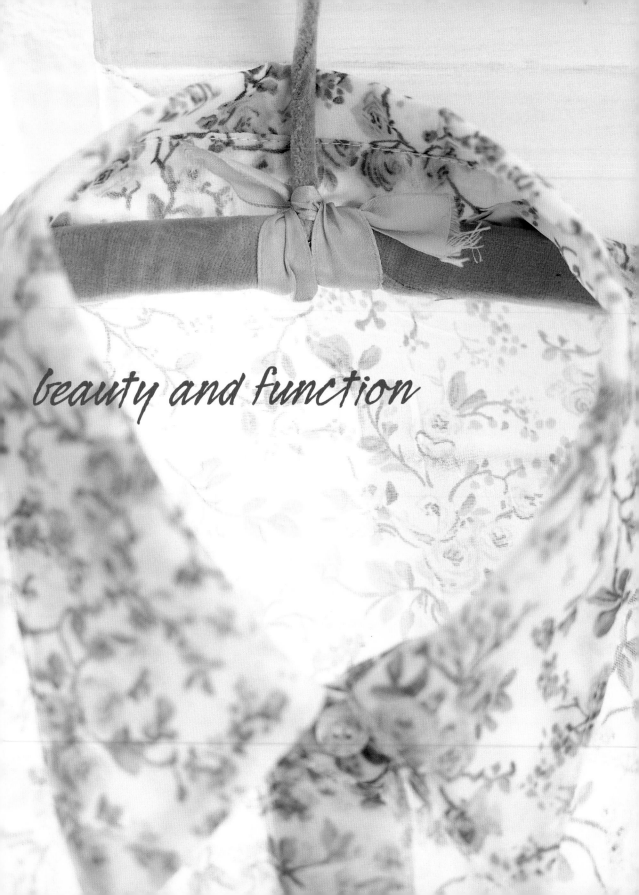

beauty and function

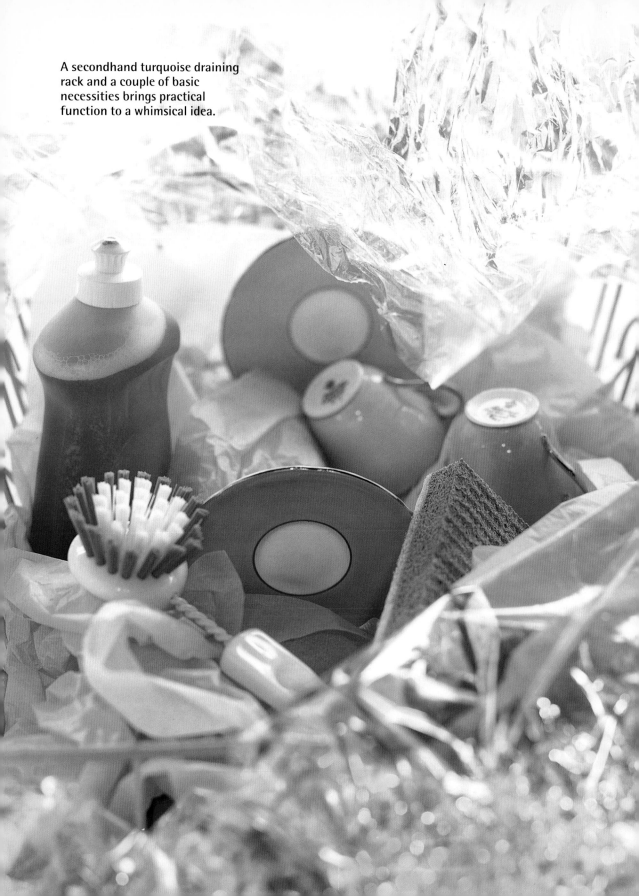

A secondhand turquoise draining
rack and a couple of basic
necessities brings practical
function to a whimsical idea.

This would definitely be a fun housewarming gift. Perhaps it would be for someone just moving into a first apartment. The core and main cost of this present are the lovely bright coffee cups.

charming!

Scooping up the whole package in some colored cellophane and plopping a Shabby Chic rayon and velvet flower on top is quite charming, I think.

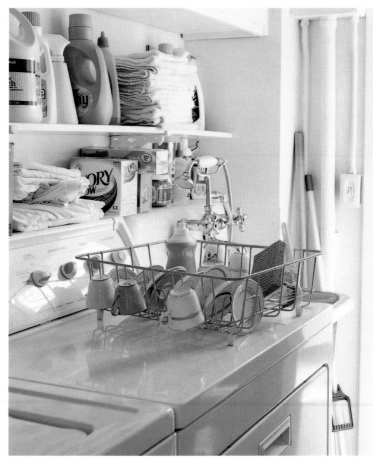

Getting to see the present used in its new home is always satisfying. Here the dishes and dishrack are being used in the washroom.

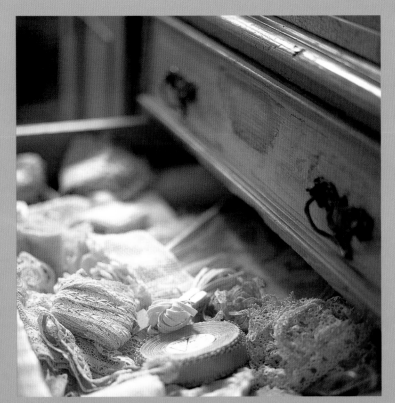

Rummaging for goodies to use as gift wrap is always fun for me. It reminds me of being out with my mum in England, looking for bits and bobs for her projects. Finding those dreamy drawers filled with treasures always evokes such a feeling of discovery. What's more luscious than a drawer of old lace?

Bows and Ribbons

Sometimes I choose simple adornments, sometimes quite ornate ones. While vintage ribbon and floppy flowers are my favorites, they do seem more appropriate for a female recipient. I try to be creative about it, but I also focus on the taste of the person the gift is intended for. In my stores, we use strips of ripped cream muslin instead of ribbon over plain brown boxes. Cream paper roses top off our packages. It's very elegant and works for either a man or woman.

Opposite: A vintage floppy flower is the signature mark of a Shabby Chic gift. It's a gift in itself as well as a lovely adornment.

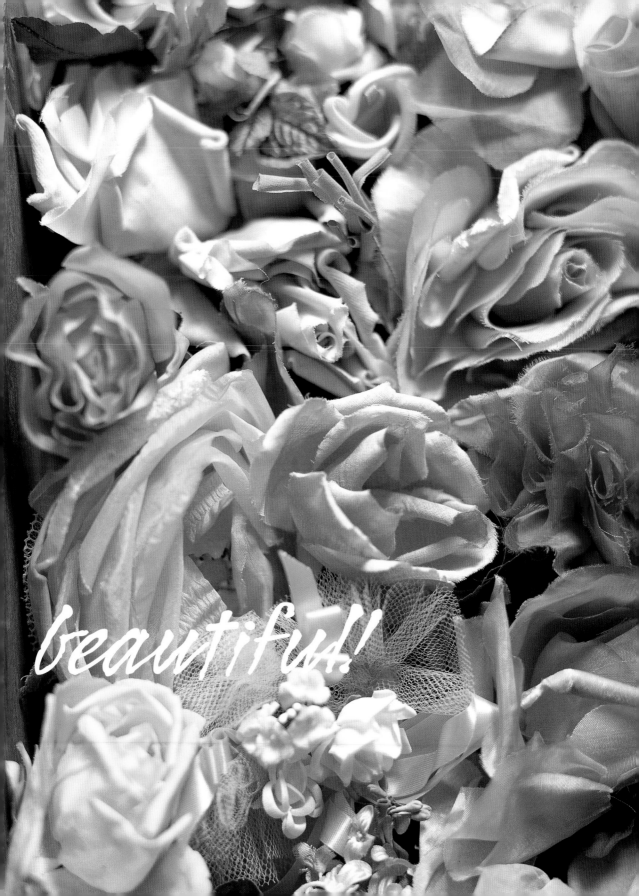

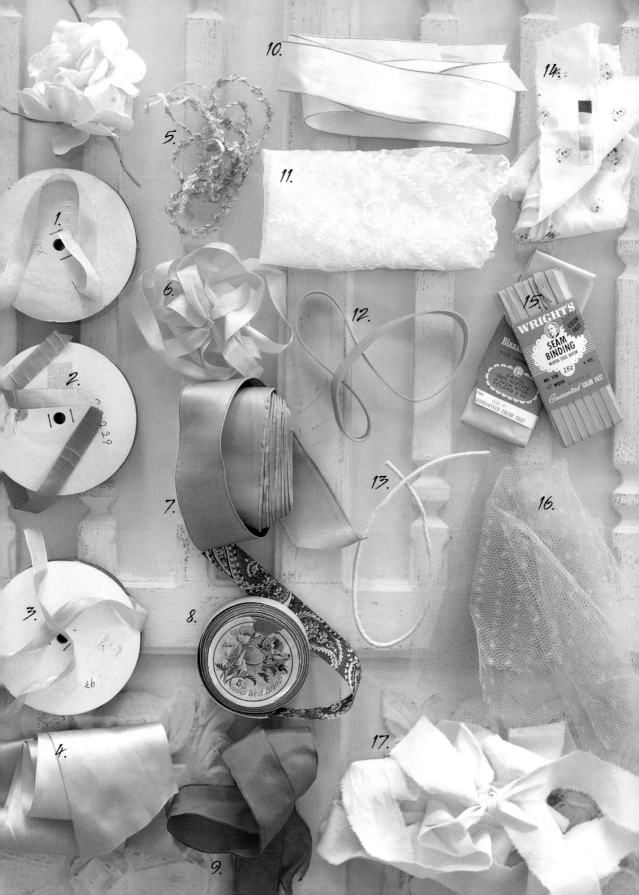

10.

14.

5.

11.

1.

6.

12.

15.

WRIGHT'S

SEAM
BINDING
WOVEN EDGE RAYON

NO. 308 15¢
½" WIDTH 4 YDS.

Guaranteed COLOR FAST

Blanke
4½ YARDS

SATIN
100% ACETATE
LINEAR WOF
FOLDED 2 IN

794
GUARANTEED COLOR FAST

2.

7.

13.

16.

3.

8.

5¢
Golden West Brand

4.

9.

17.

A variety of items
used for tying a present:

1. Pink hem tape

2. Sage green hem tape

3. Lavender hem tape

4. Yummy wide pink ribbon:
 this will be hard to part with

5. A yard of little flowers strung together

6. A pile of pale blue hem tape

7. Thick, scrumptious faded blue ribbon

8. Old French paisley silk ribboning

9. New ribbon with vintage effect

10. New white silk ribbon with gold trim

11. A bit of white lace trim:
 lace trim always comes in handy

12. Extra thick and big rubber band

13. Thick string from a great ball

14. Torn fabric: love the color keys
 down the side for character

15. Vintage packets of seam binding to use
 as ribbon: perfect colors—love the packets

16. Pale pink and green tulle: bunch it
 together and make your own bow

17. Ripped muslin fabric:
 ripping makes pretty edges

Always keep bits of tulle
around. You can buy it for next
to nothing at fabric stores.
Or pick up old, funky petticoats
and cut as needed. I like to use
it for ties on gifts or instead
of tissue paper inside a box.
It's a fabulous material.

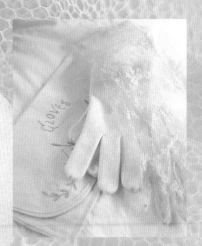

When I found this lovely linen
embroidered envelope with pink
lacy gloves, I knew it would
work well with a pair of new
creamy cashmere gloves.

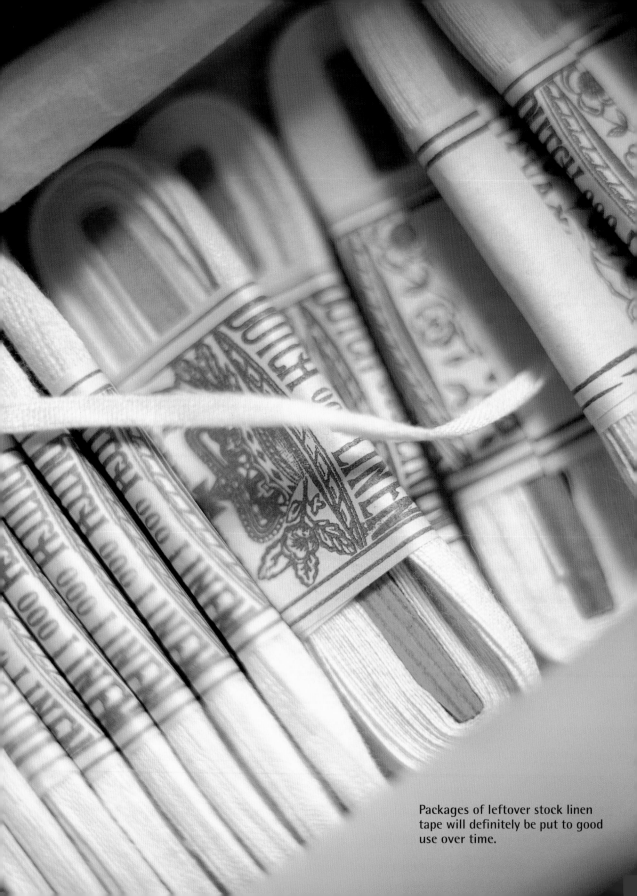

Packages of leftover stock linen tape will definitely be put to good use over time.

A magazine subscription is a good gift to give—especially if you don't know the person for whom the gift is intended very well. A personal touch, however, would be to include a beautiful bookmark. It shows more effort than just filling in a form for the magazine, and it makes the gift a bit more personal.

Silk ribbon, whether extra wide or slender as can be, evokes thoughts of glamorous and traditional occasions. A wedding or ballet comes to mind. Its nature lends itself to making beautiful bows easily.

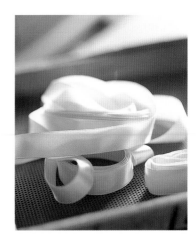

HAPPY BIRTHDAY

MERRY CHRIS

Personalizing anything makes the recipient feel special. You can do this on a variety of materials: a feather with a stamped message is a gift all by itself.

The Card

The final element of a gift is the card. So often cards are treated as afterthoughts. To me, they're very special and meaningful; in some instances the card can even be the gift. The thought of making cards can be overwhelming, both creatively and time wise, but like anything, with the correct preparation and time allotted, it can be achieved. The process can actually be quite therapeutic. The elements to consider when making cards are paper stock, writing instruments,

and accents. I like to be diverse with what I use to write; I've used everything from rubber stamps to embossers to watercolor paint pens to a plain lead pencil. As for what to write on, anything from a plain paper card to a feather serves the purpose. For the adornments, I use everything from photographs to flowers to ribbon to stamped sealing wax. It's easy and it's actually quite fun—a chance to be really creative. Do keep in mind that if the adornments are fragile, special arrangements might need to be made with the post office. For example, when mailing a card decorated with sealing wax, be sure to request that it be hand-postmarked. I know from experience that if it goes through a postmarking machine, the wax will crumble and end up like colored sand in the envelope. These types of gestures are worth all the effort. I cherish cards that have been made for me. I consider them treasures.

I love this beautiful old box of stamps. I didn't buy this one, but I did buy some individual stamps.

A black-and-white photo attached to card stock with photo hinges is simple and lovely. Add a little beaded flower somewhere.

to your days devo...

...you and each year.

...troops of friends

...love that I ... your life to cheer.

...lives attend.

...friend.

...from...

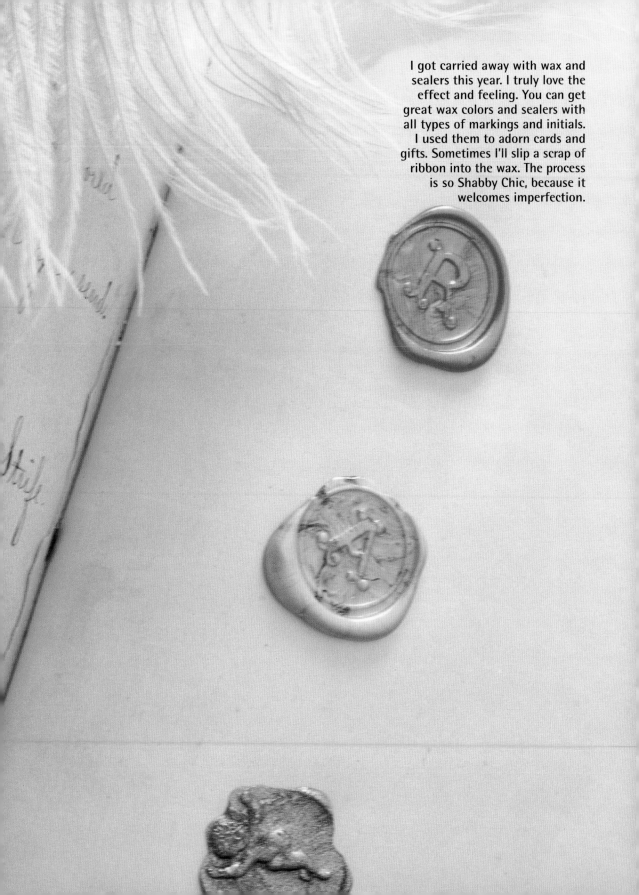

I got carried away with wax and sealers this year. I truly love the effect and feeling. You can get great wax colors and sealers with all types of markings and initials. I used them to adorn cards and gifts. Sometimes I'll slip a scrap of ribbon into the wax. The process is so Shabby Chic, because it welcomes imperfection.

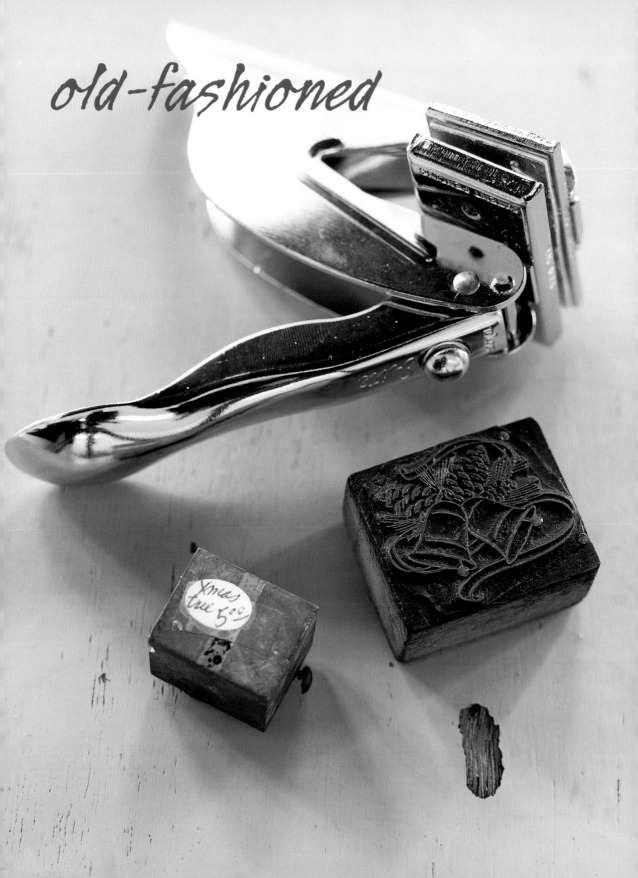

old-fashioned

Xmas
true 5⁰⁰

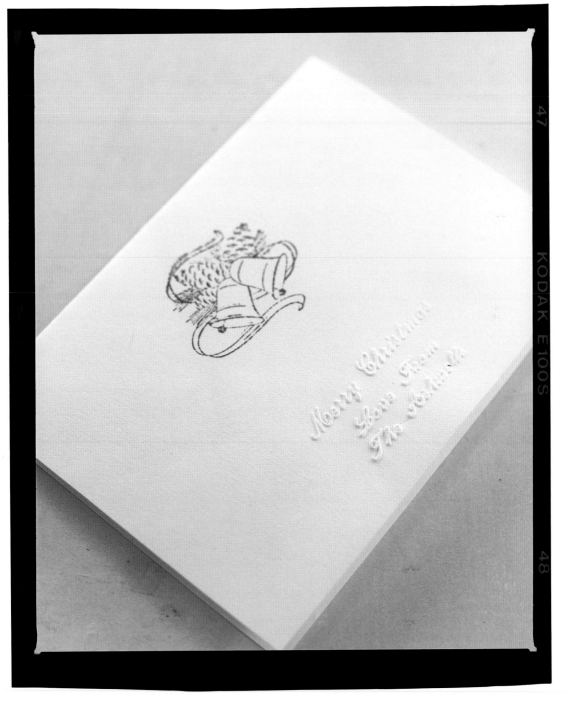

I love the irregularities that old stamps create. A combination of new or vintage stamps and an embosser complement each other for a truly elegant but old-fashioned card. Both are truly classic. Embossers can be purchased at stationery stores or on the Internet starting at about twenty-five dollars.

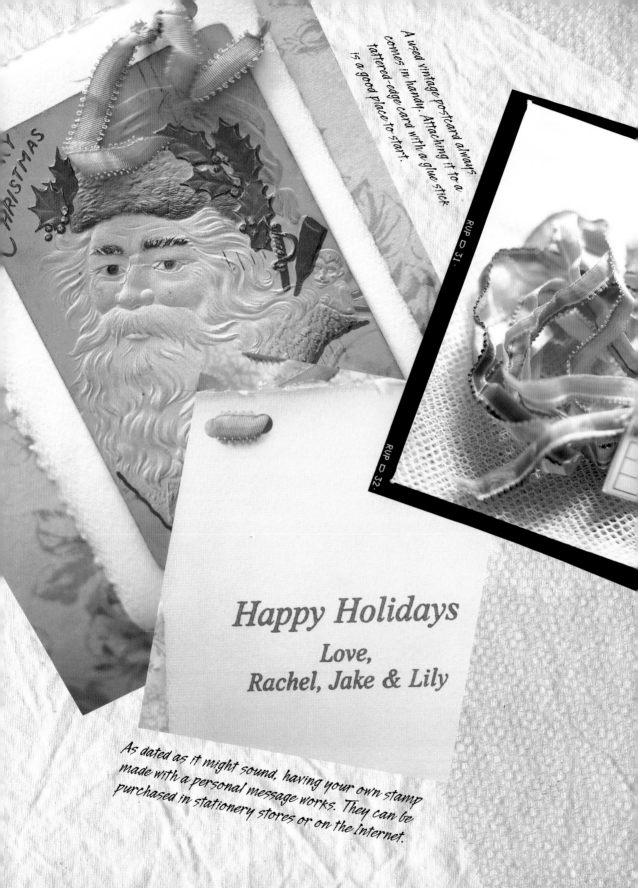

A used vintage postcard always comes in handy. Attaching it to a tattered-edge card with a glue stick is a good place to start.

RVP ▷ 31.

RVP ▷ 32.

MERRY CHRISTMAS

Happy Holidays

Love,
Rachel, Jake & Lily

As dated as it might sound, having your own stamp made with a personal message works. They can be purchased in stationery stores or on the Internet.

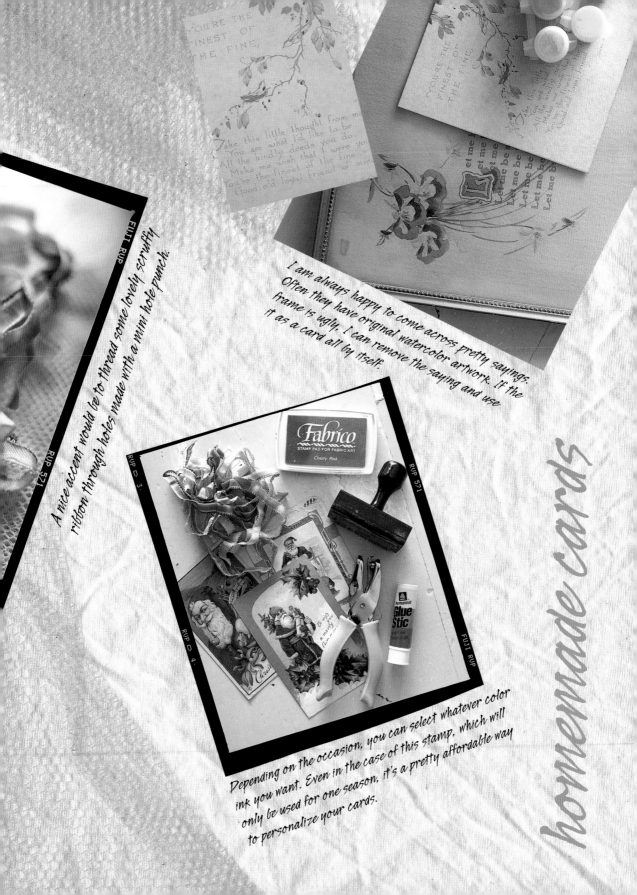

I am always happy to come across pretty sayings. Often they have original watercolor artwork. If the frame is ugly, I can remove the saying and use it as a card all by itself.

A nice accent would be to thread some lovely scruffy ribbon through holes made with a mini hole punch.

Depending on the occasion, you can select whatever color ink you want. Even in the case of this stamp, which will only be used for one season, it's a pretty affordable way to personalize your cards.

homemade cards

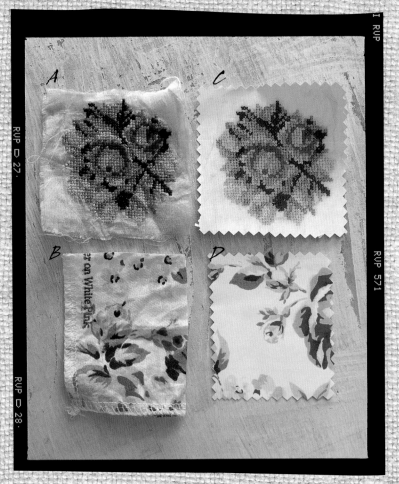

A

C

B

D

If you don't want to part with fabric or bits (A, B) you might find, you can make color photocopies (C, D) of them and use them in the same way you would use fabric. This is also a great way to make your own wrapping paper.

so easy

Even though pansies and yellow ribbon are not my favorites, the concept of this card has inspired me to make my own version. Vintage stuff often gives me good ideas.

Just to say
Hello –

I carry a line of greeting cards in my Shabby Chic stores. The cards are made up of scraps of Shabby Chic fabrics, glued to card stock that can be found in any art supply store, and completed with ribbon wrapped through the inside flap of the card. It's so easy.

Buds, Blos

4

soms, and Blooms

Gathering and placing flowers,
innovative holders, and arrangements

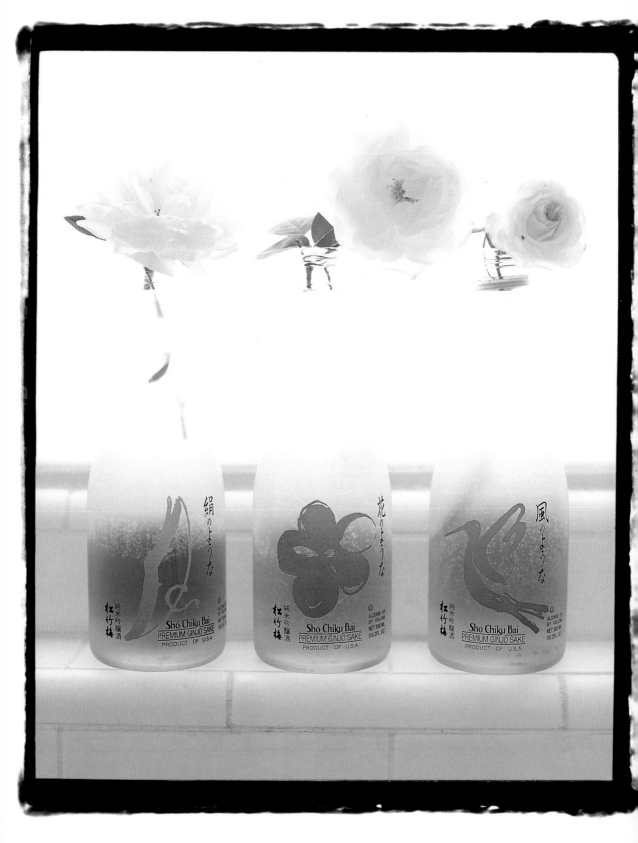

F lowers are everywhere. Whether they are printed designs on fabric or on wallpaper, landscaped in a garden, or wild in a field, their beauty inspires me. How different a place the world would be without them! Appreciating them as I do, it's easy for me to see truly what wonders of nature they are. They're timeless. Roses, for example, go back hundreds of years. Many are much the same as they were in the sixteenth century. I am certainly inspired by them both in my working and personal worlds. I even named my daughter, Lily, for the flower. How appropriate that name has turned out to be, for she has the fairest of skin and is willowy and graceful, just like the flower.

Flowers are such a big part of my world that it's natural I give them often as gifts. The colors, textures, shapes, and fragrances are so wonderful and diverse. Because I find them so yummy, I love to find elements with which to present them that are every bit as appealing as they are themselves.

Opposite and above: I love these Japanese sake bottles. The back-side of the labels creates the hues of color. They're beautiful, elegant, and cost almost nothing.

willowy and graceful

When I am giving a floral gift, rather than present a wrapped or boxed bouquet, I'll often include a vase or some sort of pretty container to hold the flowers. I like to use unique containers instead of the standard type you usually get from a florist. They don't have to be expensive at all; most of the time I find the vases at flea markets. This generally allows me to find one-of-a-kind items that cost only a few dollars. I also am a firm believer in finding things that may not have been intended for use as a vase but that serve the function beautifully. I've used teacups, bottles, and bowls—anything that can hold water and looks pretty. Giving flowers in this way makes the gift more lasting. After the flowers have gone through their life cycle, there's always going to be that lovely vase or cup that can hold new flowers.

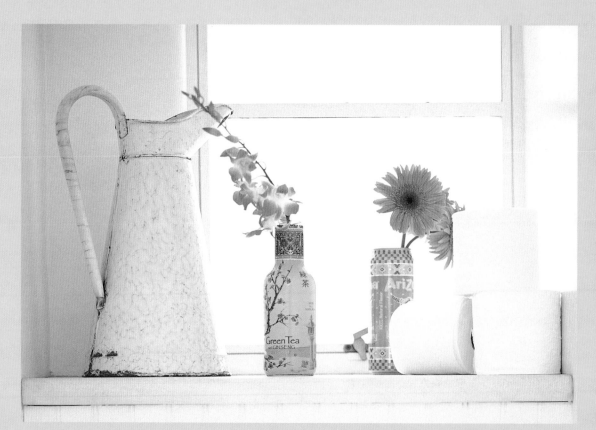

I'm always on the lookout for interesting containers that can hold flowers, both for myself and for interesting yet inexpensive ways to present flowers to someone.

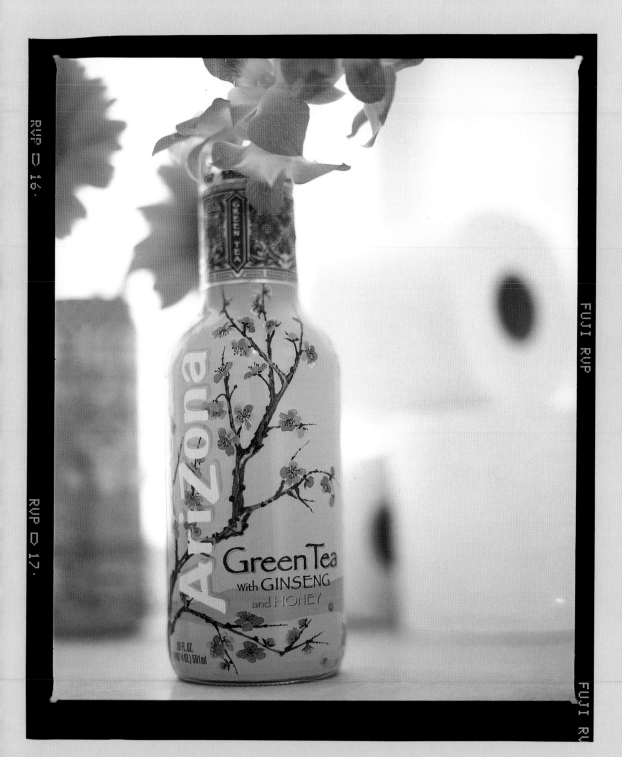

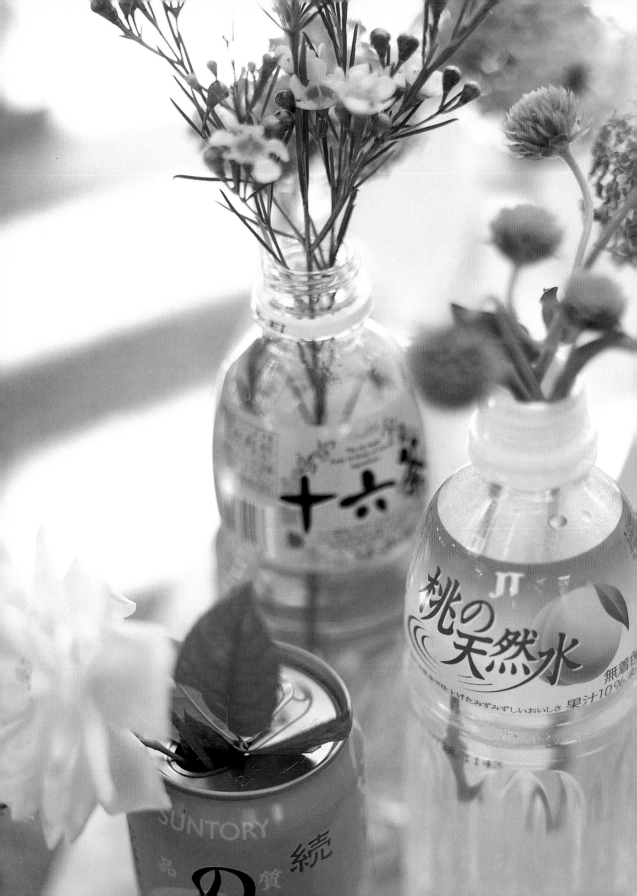

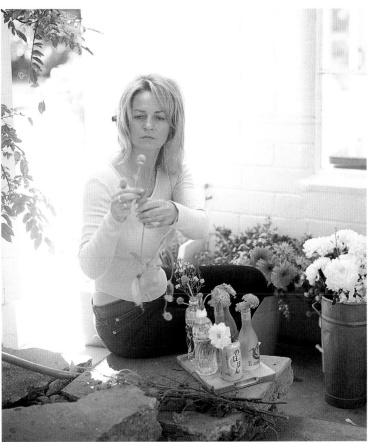

The colors of these Japanese soda cans and bottles fit perfectly into my palette. They are charming containers in which to present little wildflowers, whether for someone else or for myself.

Giving someone a flowering plant is another nice way to give a floral gift, especially if the plant lends itself to being cut for an arrangement, like miniature roses or hydrangeas. I like to include a vase or two with the plant. That way, the person for whom the gift is intended can cut the flowers themselves and make their own arrangements.

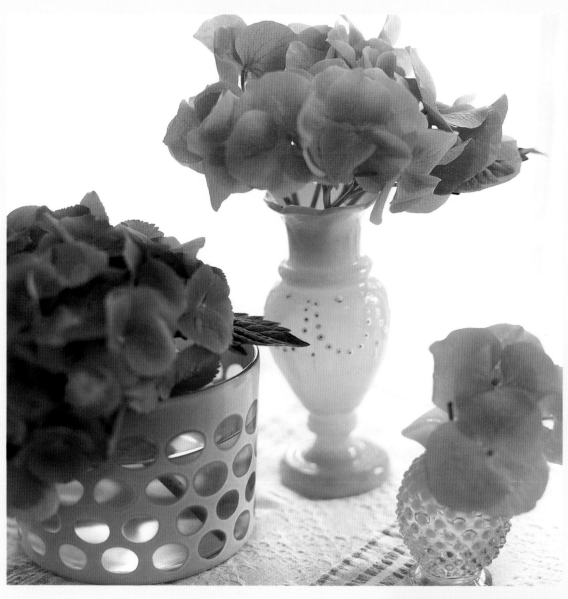

I like the idea of giving a selection of three vases as a gift. The presentation of cutting up one hydrangea plant into three stems, putting them each in a separate vase, placing them all into a cardboard box, and then tying a pink ribbon around the box finishes off my thought. Fancy bows and gift wrap would have taken away from the vases.

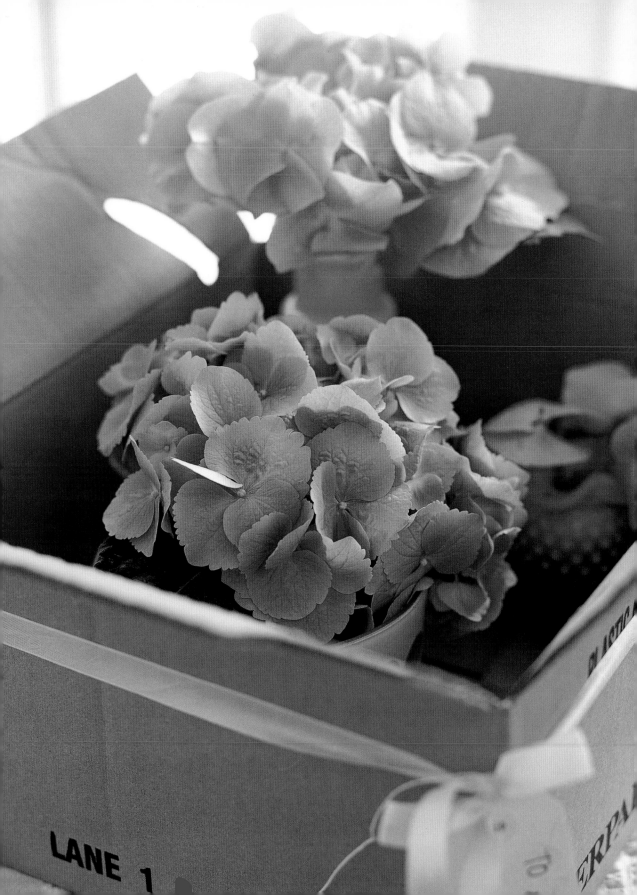

LANE 1

Three jars tell a simple story. One has a glamorous but broken sprig of an orchid. The effect of crushed ice at the bottom of another jar makes for a cool and refreshing display to house a simple leaf. An old spice jar accommodates a sprig of leather fern, which will last nearly forever.

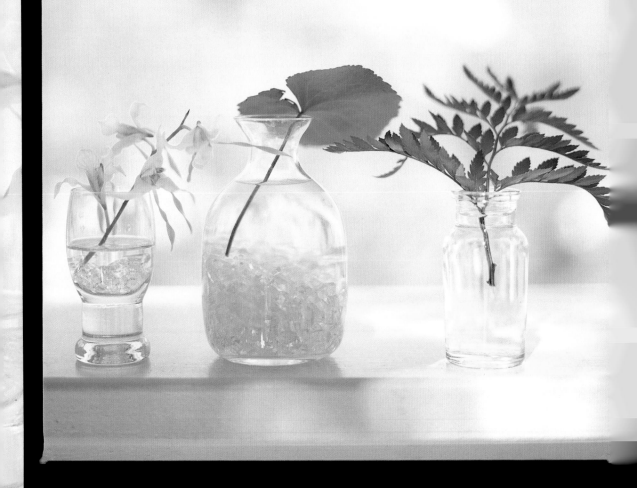

Men and Flowers

Men and flowers can seem like a contradiction in terms; because flowers are so pretty, they're often thought of only for women. Most men are intimidated by receiving or arranging them themselves. I think, however, that men can enjoy them just as much if the choice of flowers and presentation is right. I wouldn't expect to see bunches of pink garden roses on a man's bedside table, but a single orchid plant in a handsome container is perfectly acceptable in a man's home. I also have found that men's arrangements can be very easily put together using greenery such as bear grass or leather fern rather than actual flowers. I once put together a collection of green leaves in a variety of clear glass vessels and gave them as a gift to a guy friend. I showed him how to achieve what I had done by keeping it simple. Along with truly bringing beauty into his home without challenging his masculinity, it opened his eyes and thoughts to how he could do this for himself without seeming too girly. It's a bit unorthodox as far as flower arrangements go, but it can be every bit as beautiful.

Here I used two plain old jars, one with stones and the other with clear marbles. For just a few pennies, I purchased some tall bear grass and fluffy Ming fern.

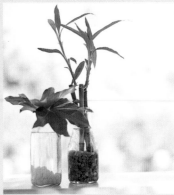

A milk bottle I found for almost nothing at a flea market with some white marbles holds an alleyway leaf. The other milk bottle holds a couple of branches of lucky bamboo—three together are thought to bring happiness, wealth, and longevity—supported by being nestled in with some brownish pebbles. No maintenance at all, except fresh water every now and again.

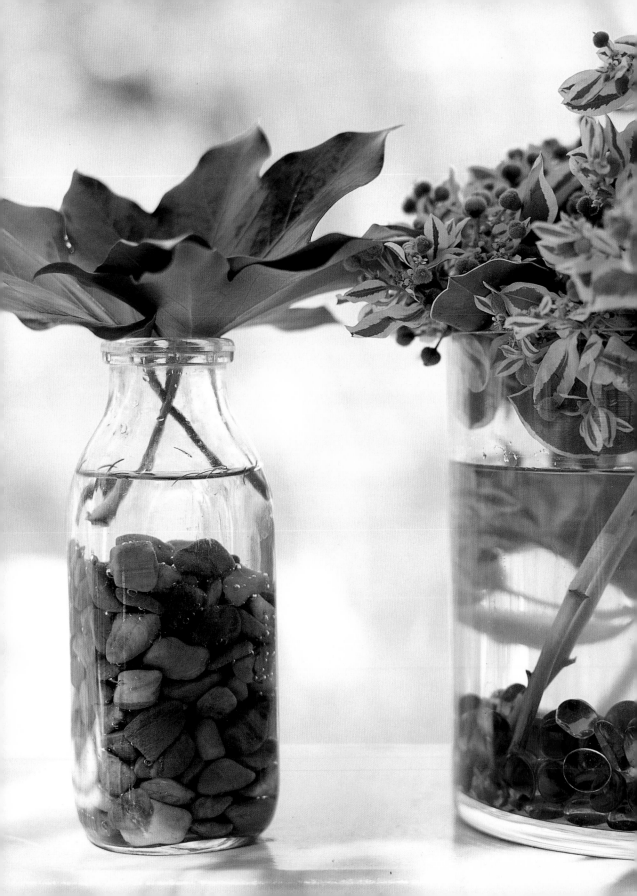

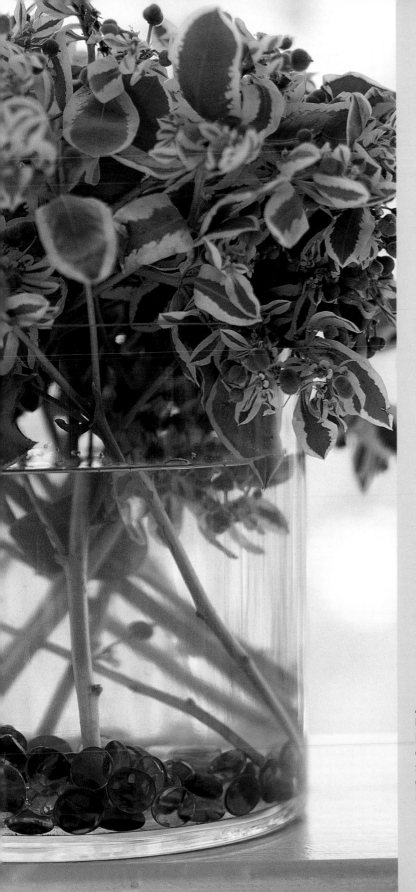

A huge round pot is filled with
blue and green glass marbles.
I decided to put a bushy type
of leaf in here to make a bigger
statement. A milk bottle with
gray pebbles and a few leaves
is so simple, yet very handsome.

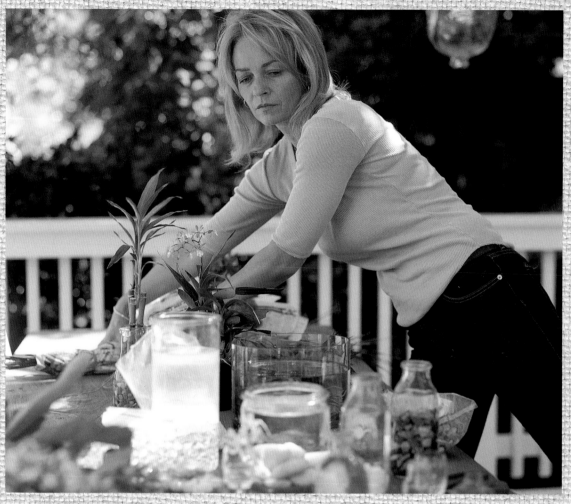

Getting some leaves off trees and bushes in an alleyway, going to a florist for some filler and a few marbles, a pet store for some aquarium granite, the beach for some pebbles, and my own garage for some empty jars was everything that was needed to put together a gift for a guy friend.

The concept of taking a floral gift a step further by adding effort to presenting the gift is very appealing to me. I love the idea of going into someone's home—obviously someone to whom I am very close—and placing flowers about their home for them. Wouldn't it be lovely to come home and find someone had done that for you? I know I'd love it.

Different stones and pebbles are easily purchased at florists' shops and aquarium suppliers, or simply found on nature's paths.

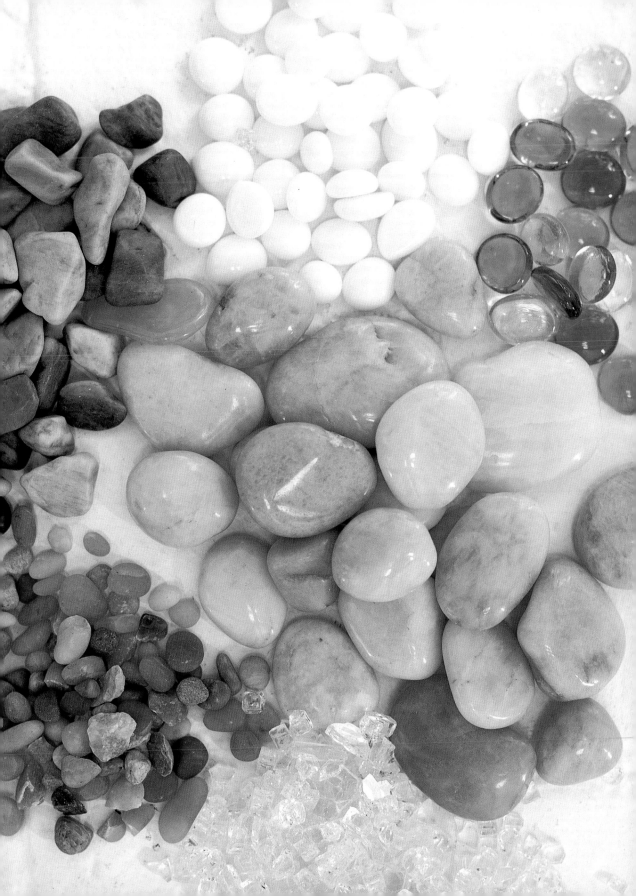

Zen Flowers

Recently, I have become attracted to the minimalist quality of Zen. Zen and Shabby Chic do share some common principles. Simplicity is the most obvious. As this applies to flowers, I like to stay with one type of flower in an arrangement, or even just a single flower. The focus on nature is certainly emphasized in both philosophies. I often display a flower in a shell, which I consider a gift of nature, or use stones and pebbles to hold flower stems in place. Accepting life as it is allows me to enjoy every stage of a flower's existence: the bud, the bloom, and the wilted flower. There's something so stunning to me about a fully opened rose with some aged and tattered edges on the outside petals. Even when the petals fall, I leave them where they lie. The last mutual characteristic, balance, is perhaps the most important. For me, this has a lot to do with placement, and allows me to be creative when decorating a room.

A couple of bright dahlias create a delightful shot of color. I popped these into a tall elegant bottle—it originally came with a stopper, but I knew it would have more use as a vase. A shared Zen and Shabby Chic approach, the arrangement has balance, in both color and space.

floral surprises

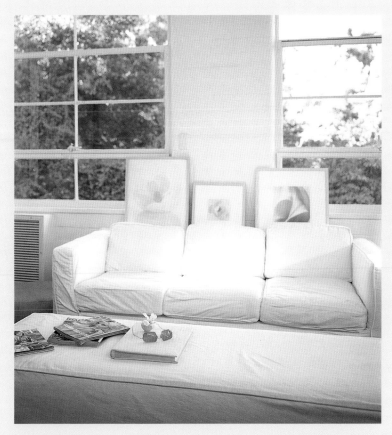

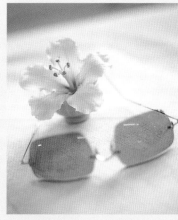

A simple hibiscus somewhat overwhelms this little bud vase, but that's okay. The simplicity of it is charming.

It's a nice gesture to gather some pretty flowers, present them in a variety of vases, and surprise someone by placing them around a room. Even though this room is what I would consider Zen-like, there's always a place for a Shabby Chic flower.

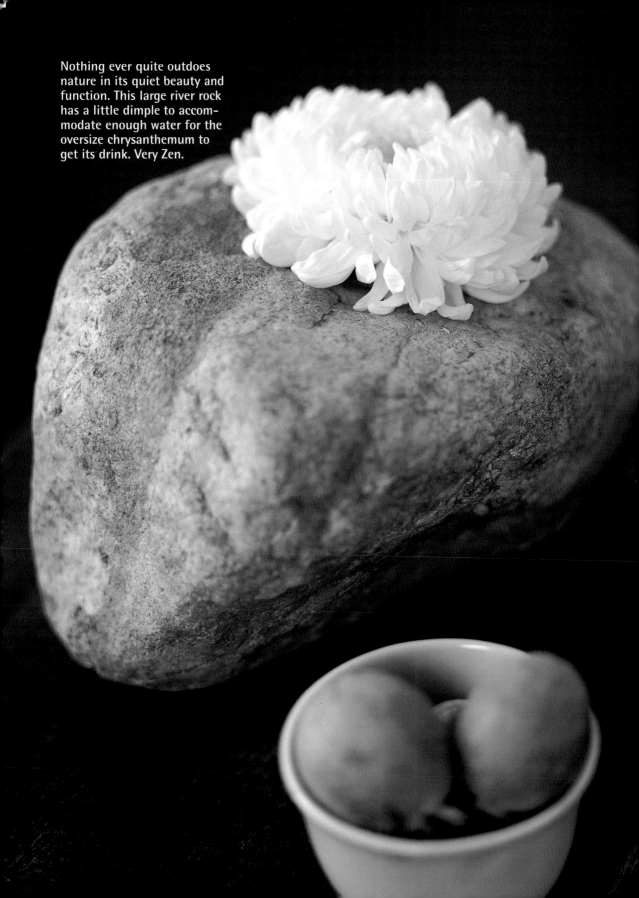

Nothing ever quite outdoes nature in its quiet beauty and function. This large river rock has a little dimple to accommodate enough water for the oversize chrysanthemum to get its drink. Very Zen.

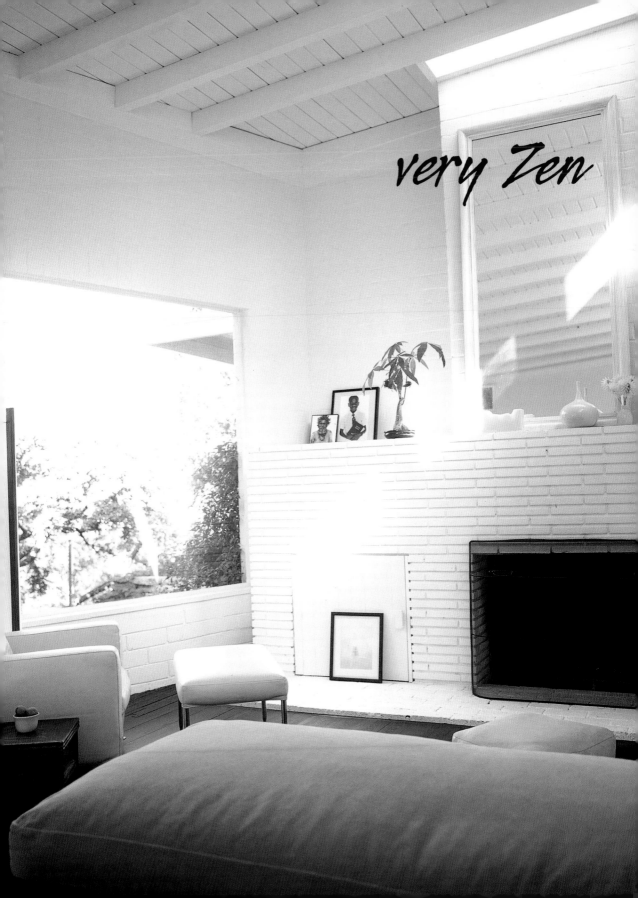

very Zen

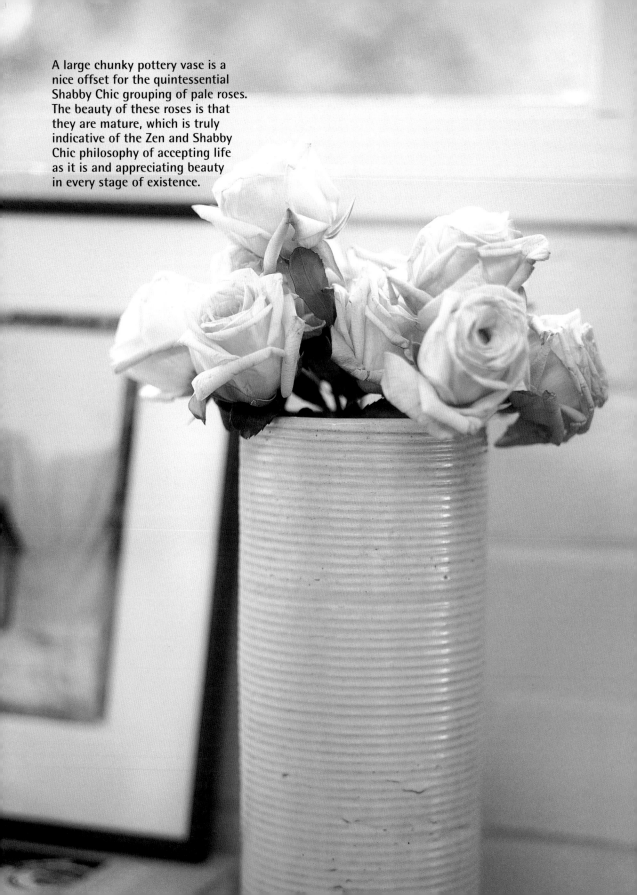

A large chunky pottery vase is a nice offset for the quintessential Shabby Chic grouping of pale roses. The beauty of these roses is that they are mature, which is truly indicative of the Zen and Shabby Chic philosophy of accepting life as it is and appreciating beauty in every stage of existence.

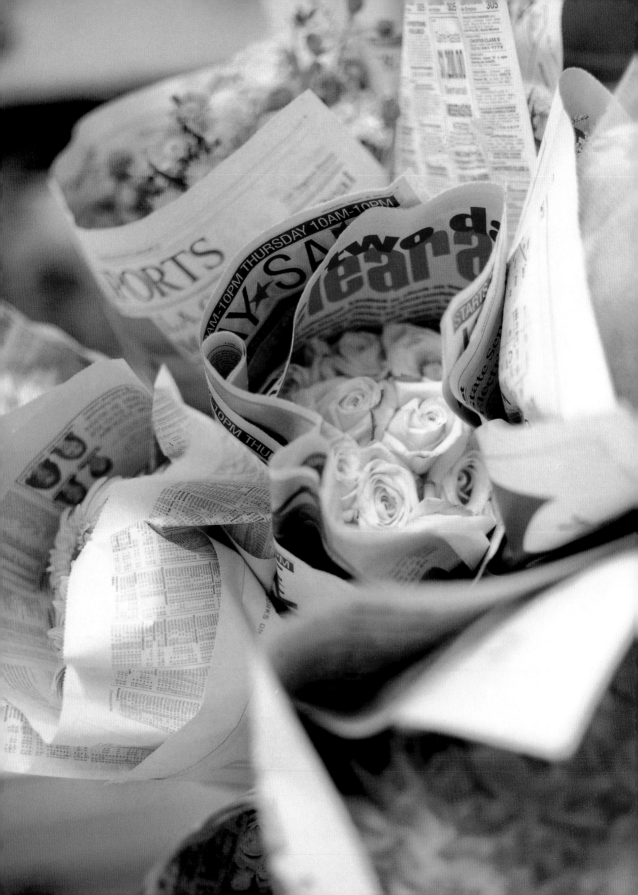

Gathering Flowers

If my garden is in bloom, my favorite place to gather flowers is in my own backyard. If my yard is not flowering, rather than relying on expensive florists, I tend to buy my flowers at either supermarkets with good selections, farms, or flower marts. I am fortunate to live in a city that has a large flower mart (check with your local chamber of commerce to find the nearest one). In addition to the selection, the flowers tend to be very fresh, so they'll live longer. But also, to me the whole experience of shopping at a flower mart is worth the effort of rising early and driving downtown. It's an incredible event. Everywhere I turn there's an excess of gorgeous flowers in multitudes of colors, shapes, and smells. And seeing all these fragile flowers amid the bustle of the market with so many people and noises is a reflection of life in balance.

colors, shapes, smells

Opposite: The colors and designs could not be reproduced so perfectly by anything man-made.

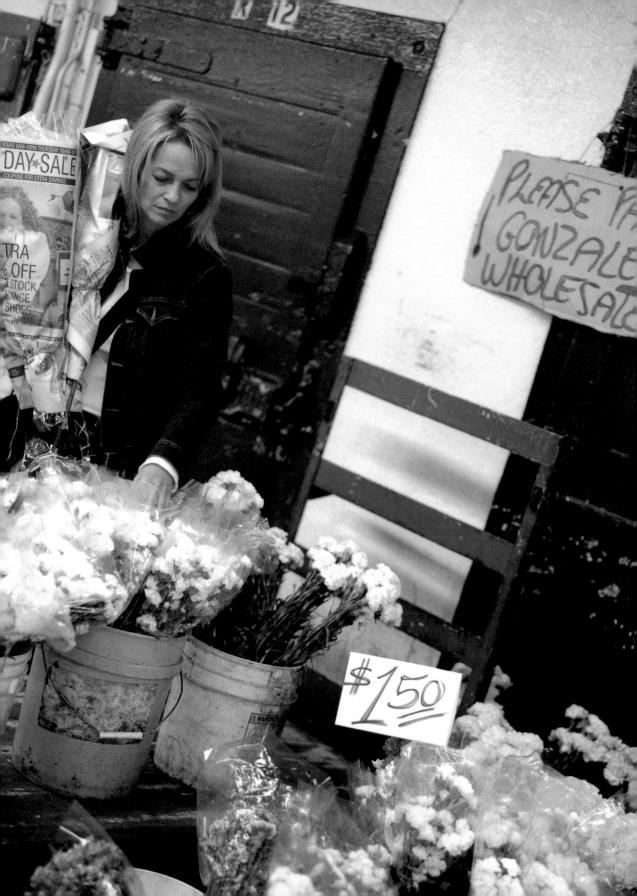

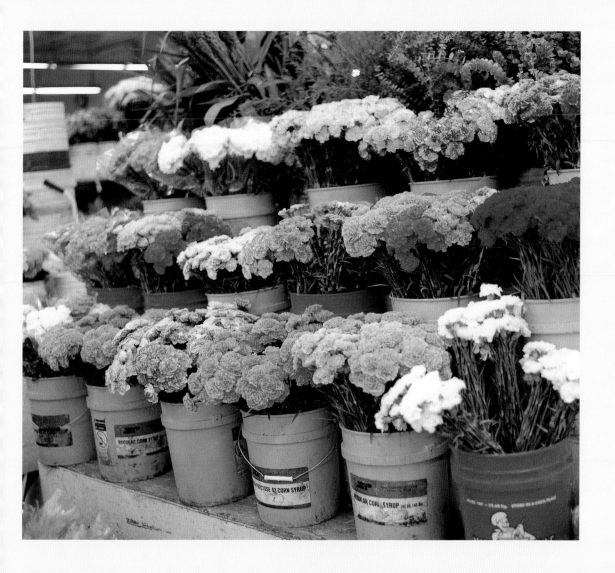

What I think is really enjoyable about the flower mart is that I've learned so much there. It's madly educational. The vendors are always incredibly eager to share their knowledge, whether it's on caring for certain flowers or what to look for in the various seasons. When I first visited a flower mart, I was overwhelmed by the abundance of flowers and I find that I experience that same excitement each time I go back. If I'm shopping for a gift here, it's certainly not a chore.

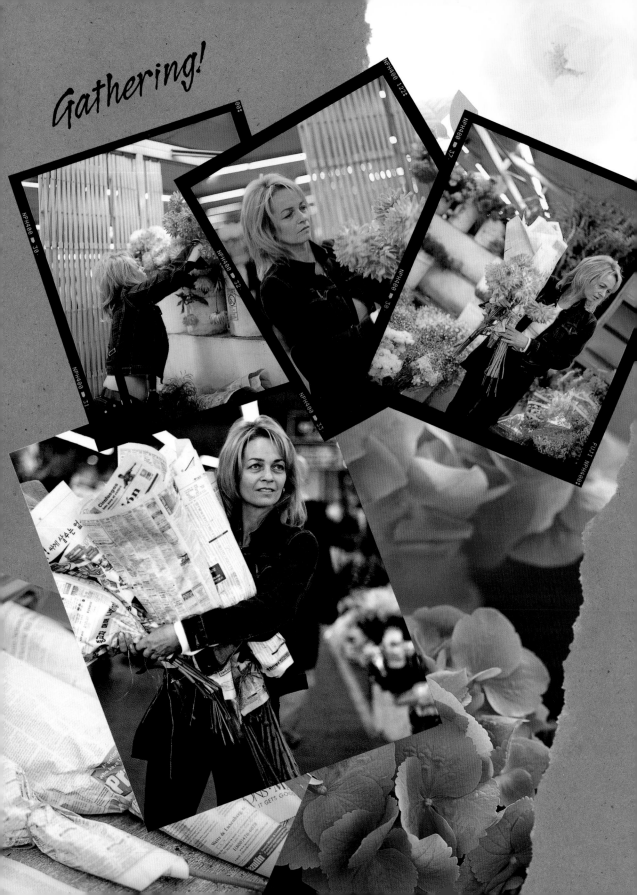

Gathering!

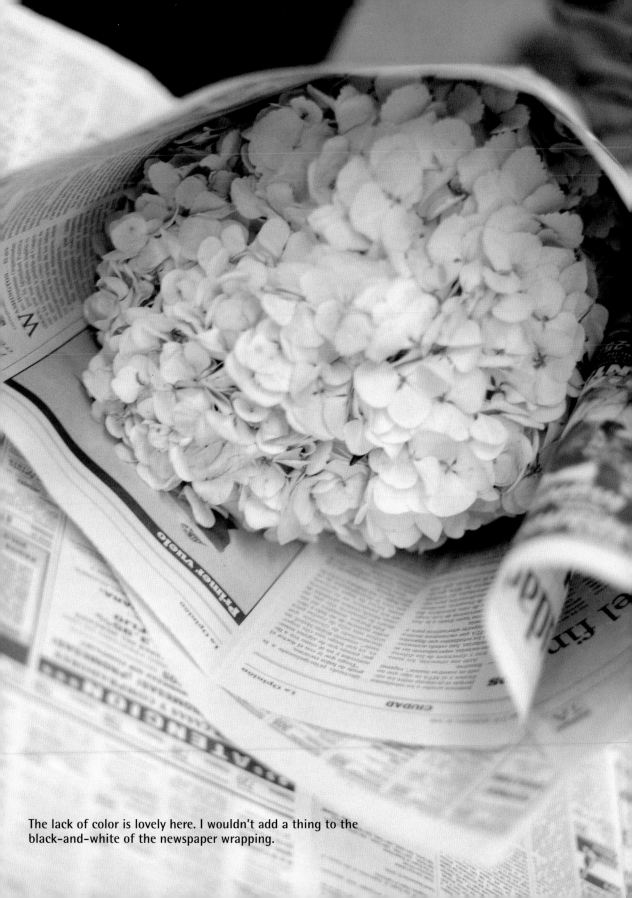

The lack of color is lovely here. I wouldn't add a thing to the
black-and-white of the newspaper wrapping.

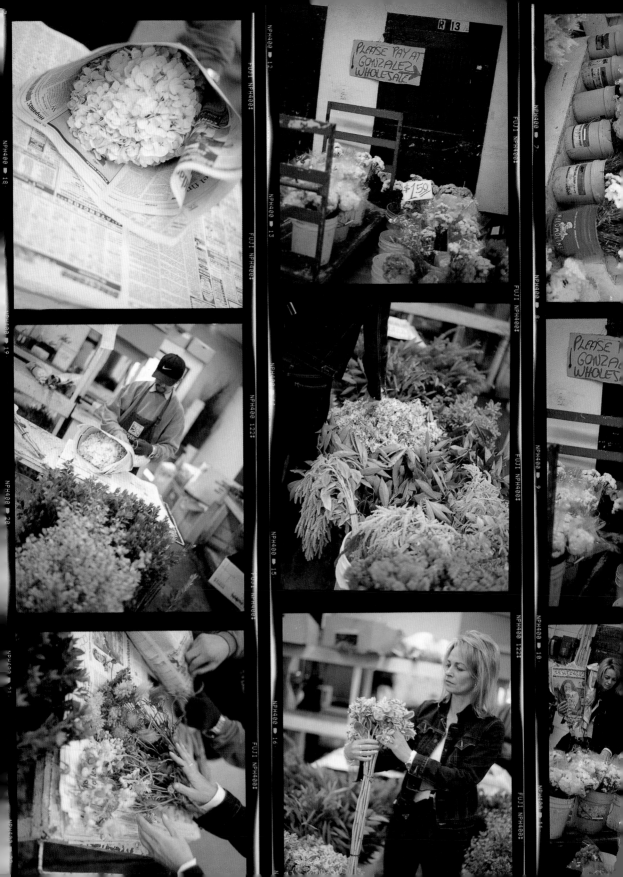

To roam around flower stores, supermarket flower departments, a roadside flower stand, a flower farm, or a garden is one of God's greatest gifts. But for me, nothing is more awesome than making my way to a wholesale flower mart. Many will let the public in at certain times. The overabundance of colors, scents, and even wrappings are just pure aesthetic joy. I believe gathering bundles of flowers for gifts is a privilege.

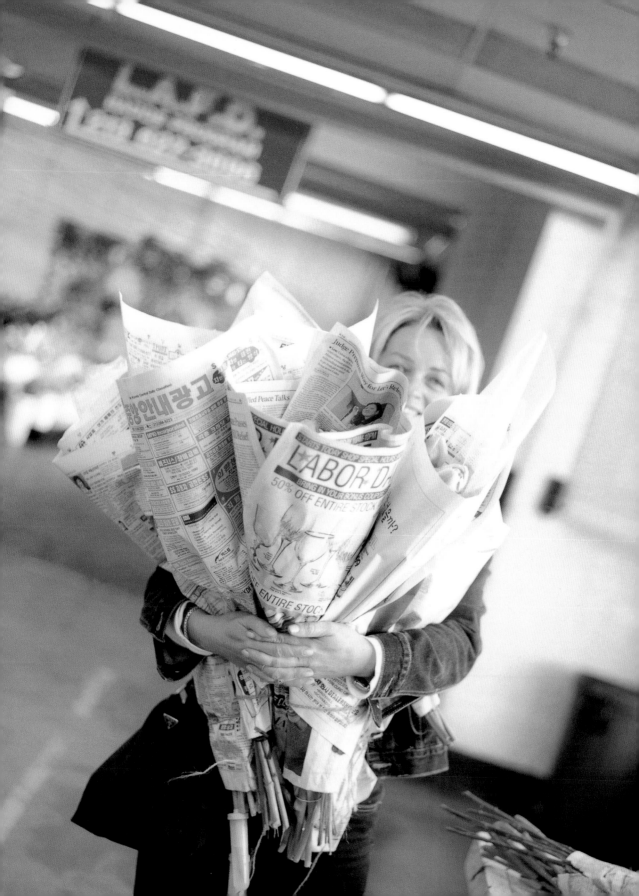

My Favorite Flowers

I am passionate about flowers. They are truly a gift of nature, and I surround myself with them. I love the way they look and smell, but I also find the meanings behind them every bit as beautiful. My absolute favorites are roses, peonies, and orchids. I am most drawn to all shades of pink, white, lavender, and purple. I usually avoid oranges and yellows.

There is literally a flower for any occasion. To give a potted hyacinth to someone who has suffered a loss is a very sweet way to acknowledge the loss and say, "I care." A camellia picked from the garden is a lovely way of saying thank you. Flowers can be given in response to a situation or an action, or to honor a characteristic of the recipient.

Camellias	*Gratitude*
Chrysanthemums	*Fondness*
Dahlias	*Dignity*
Gerbera daisies	*Innocence*
Hyacinth	*Sorrow*
Hydrangea	*Thank you for understanding*
Lilacs	*First emotions of love*
Lilies	*Modesty*
Magnolia	*Compassion*
Orchids	*Beauty*
Peonies	*Bashfulness*
Roses	*Love*
Sweet Peas	*Pleasure*
Tulips	*Appreciation*

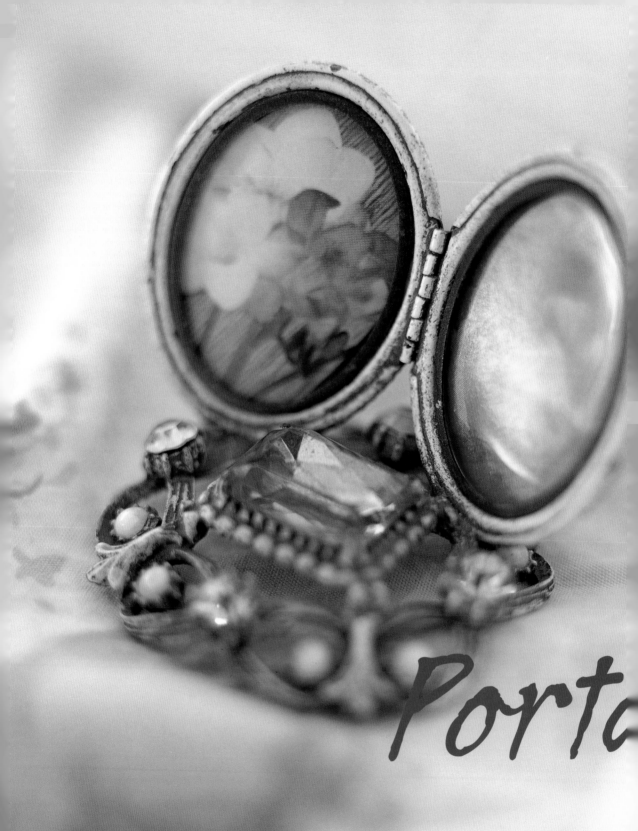

Porta

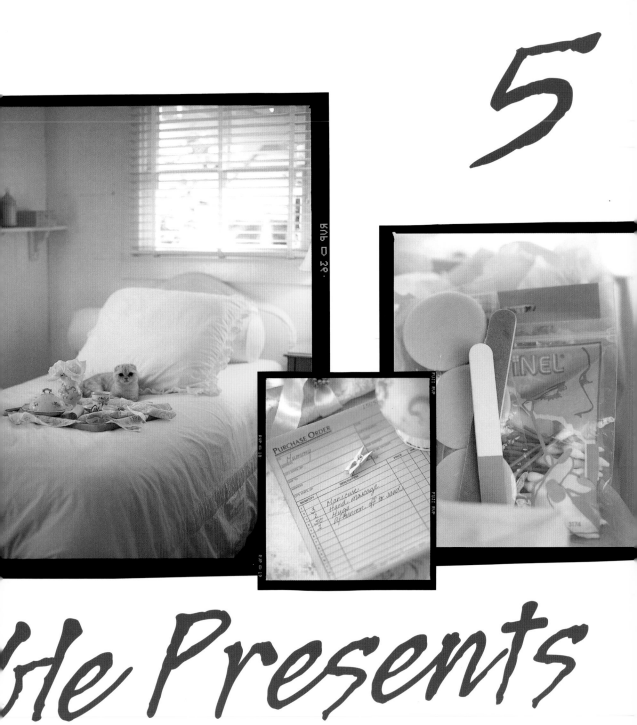

5

le Presents

Gifts of service: care packages,
packed lunches, and trays

S ometimes a gift can be as simple as a thought or service, what you can do for someone to make him or her feel special and wonderfully nurtured. These are what I would consider portable presents. They are really only everyday efforts put together in a special way to create big statements. They are things we do all the time, but with a little something more.

a little something more

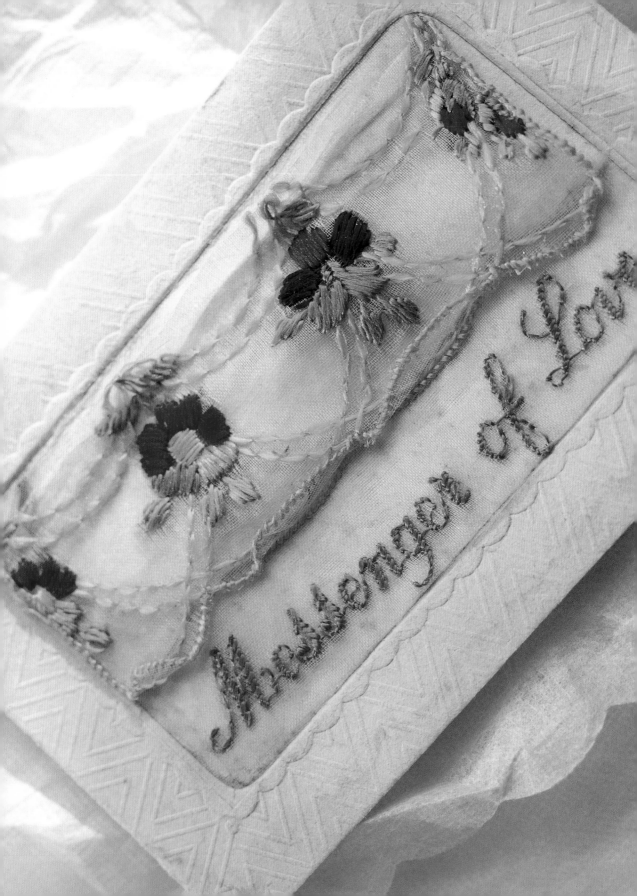

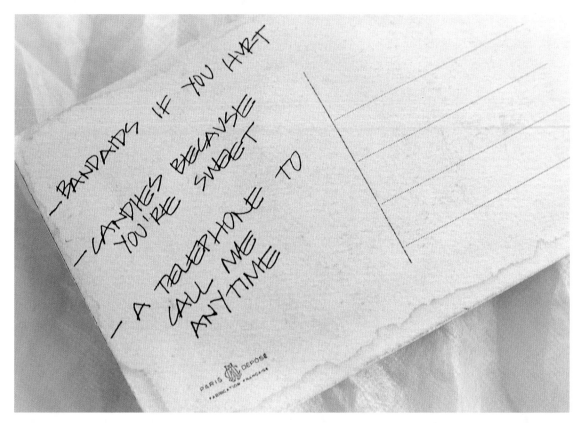

Opposite and above: I bought this beautiful hand-embroidered postcard years ago and hung on to it, knowing one day the appropriate time for it would show itself. On the reverse, I wrote the meanings behind some of the gifts in my daughter's care package.

Care Packages

The whole concept of a care package is very appealing to me. The ideals behind it, I think, are twofold. One, as with any gift, it is an expression of affection. And two, it is meant to bring comfort to someone who is away from home. With that in mind, I like to really think through all the elements I include in care packages and tailor them as best I can to the situation of the person for whom they are intended.

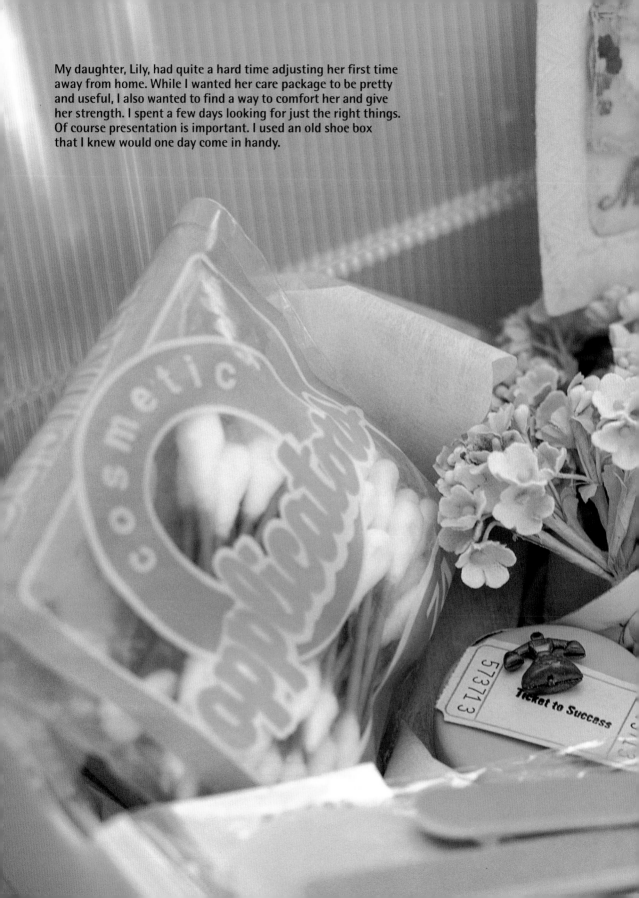

My daughter, Lily, had quite a hard time adjusting her first time away from home. While I wanted her care package to be pretty and useful, I also wanted to find a way to comfort her and give her strength. I spent a few days looking for just the right things. Of course presentation is important. I used an old shoe box that I knew would one day come in handy.

573713

Ticket to Success

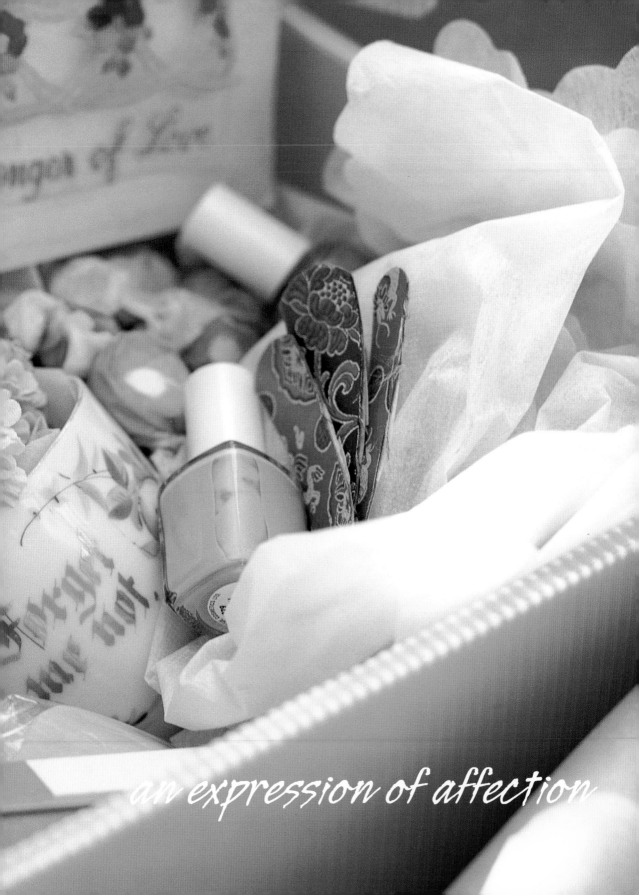

an expression of affection

When my daughter, Lily, went to camp for the first time, the reality of our being apart for seven weeks was quite a shock to both of us. While her independence was an important step to growth, we both needed some form of connection. I needed to give, and she needed to receive. Hence, the tradition of care packages at summer camp came to life for both of us. I spared no effort to put together a package that would bring her strength and comfort, and show how much I love her. By the time the second package arrived (her camp only allowed three), Lily's bunk companions were as excited as she was to see what I had dreamed up.

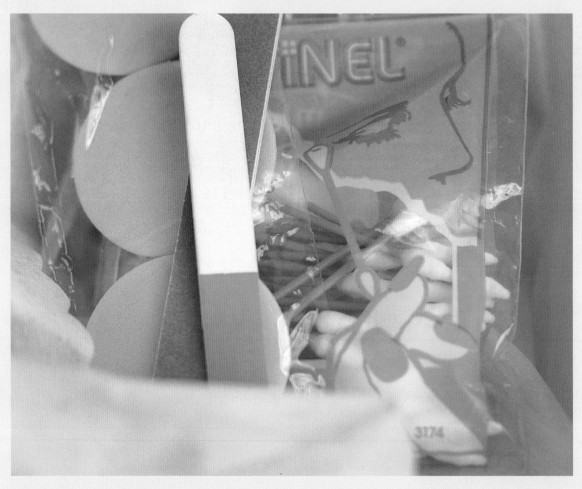

Every girl away at camp needs makeup sponges, cotton swabs, and a nail file. These were useful and fun, but also in the right color palette.

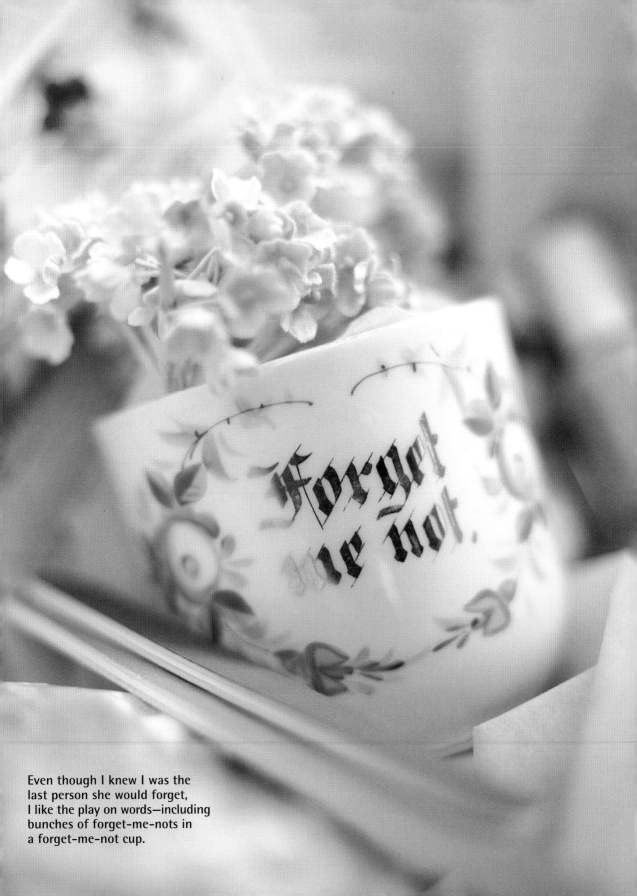

Even though I knew I was the
last person she would forget,
I like the play on words—including
bunches of forget-me-nots in
a forget-me-not cup.

Care packages should evoke thoughts of home, include needed supplies and meaningful or comforting items, and be imaginatively presented. Sometimes it's all about being useful. I am selective in what I include, though. I tend to collect a combination of new and vintage elements that might not be terribly valuable in themselves. The value is all in their collective meaning. That's what really makes a portable present work. Then it's all a matter of presentation.

While the candies may never actually get eaten, they were too pretty to exclude and convey "sweetness."

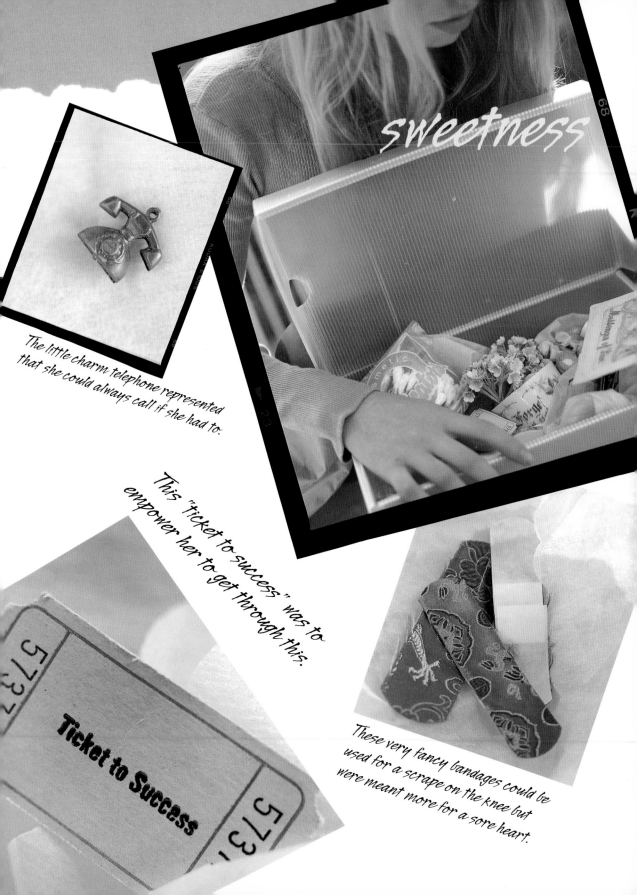

sweetness

The little charm telephone represented that she could always call if she had to.

This "ticket to success" was to empower her to get through this.

Ticket to Success

5731

These very fancy bandages could be used for a scrape on the knee but were meant more for a sore heart.

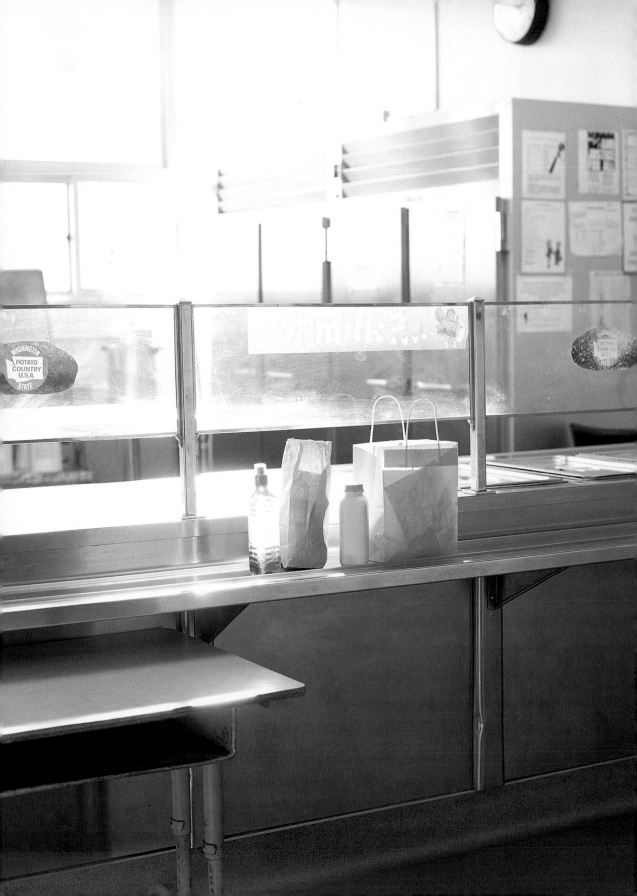

Packed Lunches

The idea behind portable gifts is to take a common task or gesture and personalize it to make it special and intimate. For me, preparing my children's lunches, what goes into them and the presentation, is a perfect opportunity to turn a task into a gift. When my children need to take their lunches to school, I take pleasure in making them myself. I know that in the middle of their day, they will have a subtle reminder that they have a mom who really thinks about them.

lunchtime!

Opposite: My children now buy their lunches at school, but occasionally a packed lunch is requested.

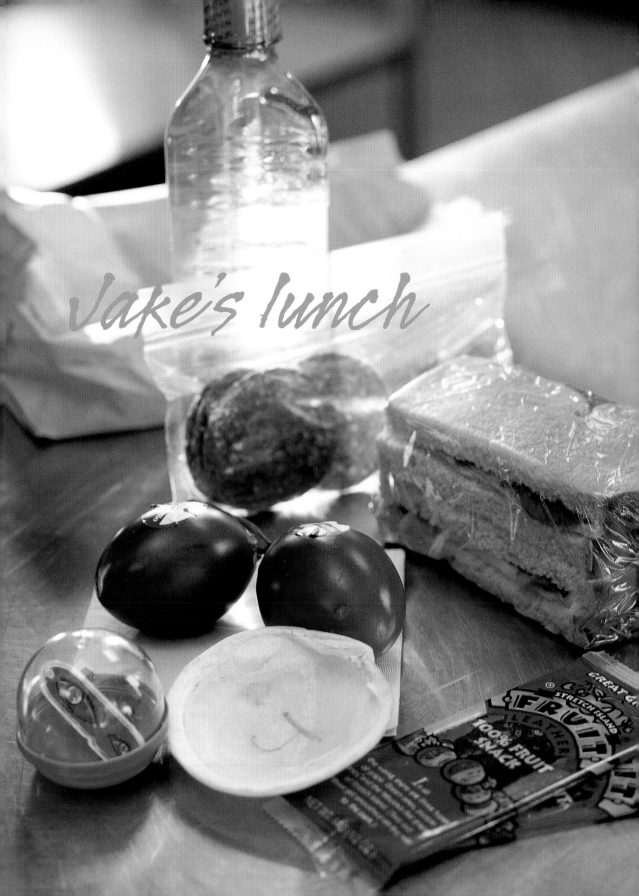

Jake's lunch

Opposite: To make his lunch subtly aesthetically pleasing, which on some level he may notice, I chose the colors of plum and green. A sandwich presented in green plastic wrap is novel. Choosing a water bottle, fruit, and snacks of the same colors are effective. The little shell with my son's initial on it is another subtle reminder that he is special to me.

My son needs to be encouraged to eat well, so any gimmick I can think of is helpful. If he had his way, he would have a fast-food meal every day, mainly to get the free toy. So, simply to ease the blow, sometimes I would include a little toy with the lunch I made him. A twenty-five cent skateboard goes a long way with Jake.

When my daughter took her lunch to school every day, I nearly always included a little note. She never threw my notes away, and always returned them in her lunch box. There were days I was too busy to write a new note, so my note of love would be used over and over again. One day I found a linen envelope, which became our note carrier.

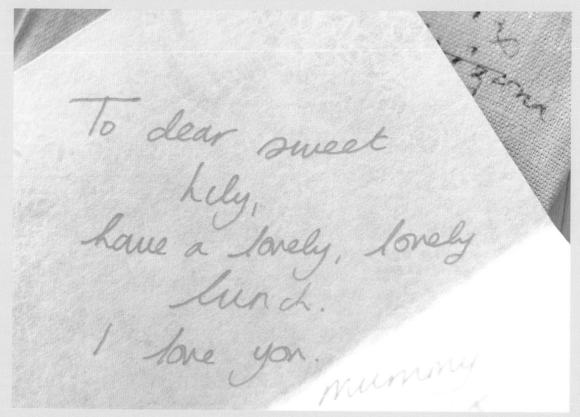

To dear sweet
lily,
have a lovely, lovely
lunch.
I love you.
mummy

As orderly as she is, she can be trusted to return home with the silver spoon and embroidered napkin.

Left: I wrapped these cookies in plain old wax paper and tied them with a simple pink ribbon. The pink enhances the general theme of her lunch since I also include pink applesauce and floral pink platters on which to rest her chopsticks (opposite). I found them in my local Japanese market.

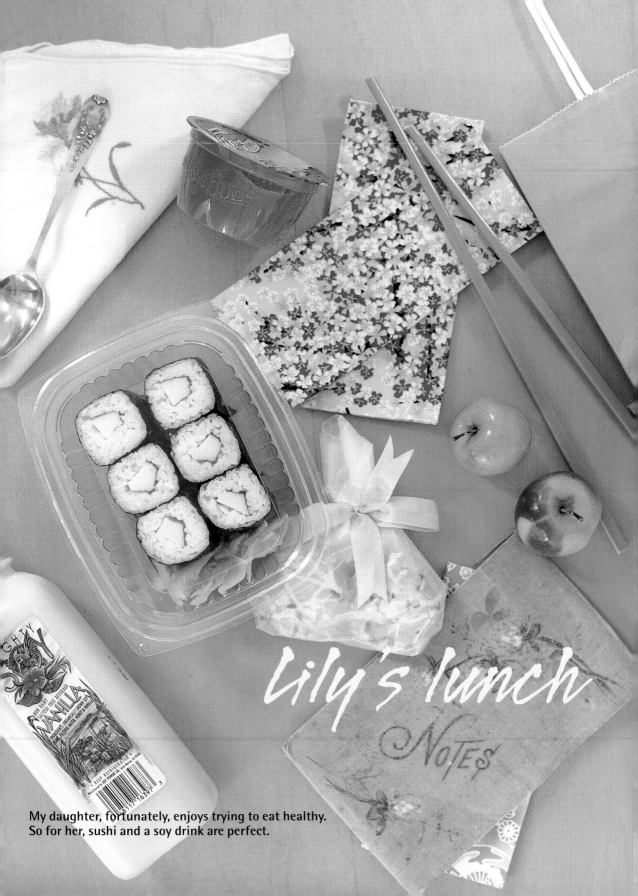

Lily's lunch

My daughter, fortunately, enjoys trying to eat healthy.
So for her, sushi and a soy drink are perfect.

Trays

Another everyday effort that can very easily be transformed into a gift is a tray of food. As with most portable gifts, trays are extravagant in love and care but not money. For me, trays fall somewhere in between care packages and sack lunches. As with the lunches, they're gestures, but I like to make them more substantial, as I do with my care packages.

I tend to layer my trays. There's the food, of course. Then there's how I present it. I approach setting a tray like I do a table. I tailor it to the occasion and the individual it is intended for. When the situation calls for it, I never skimp on using my pretty china, candles, or flowers. And finally, I like to include objects that carry on the tray's meaning, the tangible part of the gift. This could be an old book of poems or something as simple as a short note.

extravagant in love

Opposite: What lady isn't worth being pampered? My cat Mable is not a lady, but she'd like to be.
Above: I love this teeny-tiny jeweled frame.

Tea

I adore the whole ritual of a tea service.

Tea, of course, is Chinese in origin and dates

back to the beginnings of that culture.

Portuguese traders brought it to Europe in the

sixteenth century. It was the English, though,

who established tea as a social ritual in Western

culture. Anna, the seventh duchess of Bedford,

used to treat herself to a tray of tea around four

o'clock to bridge the gap between her afternoon

and evening meals. By the late 1800s the ritual

had become quite popular and was transformed

into an outright social occasion. The good china

and sterling were used, and ladies used to dress

up in all their finery. With the exception of

getting dressed up in long gowns and gloves,

the ritual remains intact.

PURCHASE ORDER

TO *Mummy*

ADDRESS

CITY, STATE, ZIP

SHIP TO

ADDRESS

CITY, STATE, ZIP

QUANTITY		DESCRIPTION	PRICE	UNI
1	3	Manicure		
2	2	Hand massage		
3	50	Hugs		
4	1	Afternoon off to read		
5				
6				
7				
8				
9				
10				

An old clip-on earring and silk ribbon create a charming napkin ring.

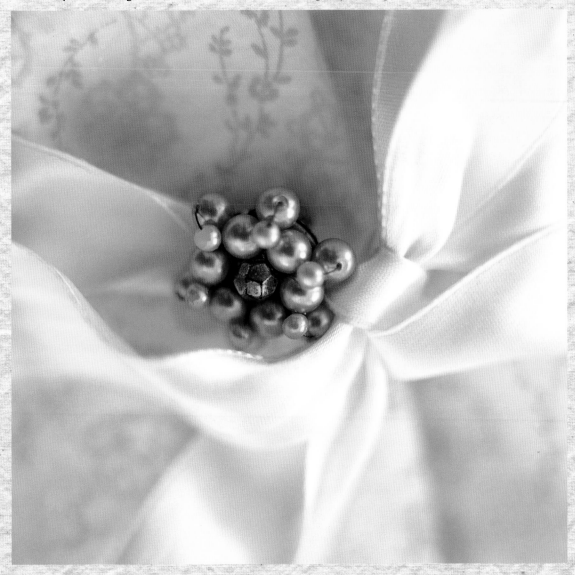

gifts of thought and service

Opposite: The biggest gift here is one of thought and service. As a mother, I love receiving these notes from my children written on an invoice.

Whether it's a tray for a family member who is ill, for a birthday breakfast in bed, or for a quiet cup of tea and cookies during a study break, trays can be a wonderful way to make a loving gesture. Tea is important to the Ashwells. My mum used to bring me a cup of tea every night, and this is now a tradition in my home.

It all goes back to the idea that any effort worth making is worth making with thought and meaning. It's simple, but it can have a large impact. There are obvious times a portable present can be given, such as a birthday, Mother's Day, or Father's Day, but I think the best occasion to give a portable present is no occasion at all.

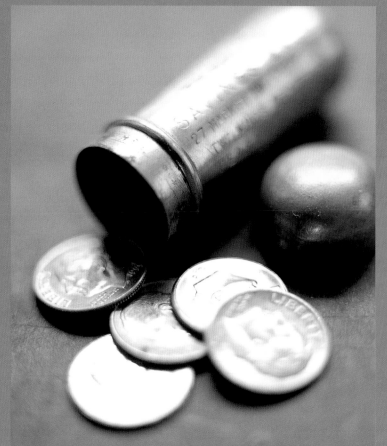

A bullet container holds some coins, to be enjoyed once the patient is up and around again.

A cough drop rests on a miniature vintage plate.

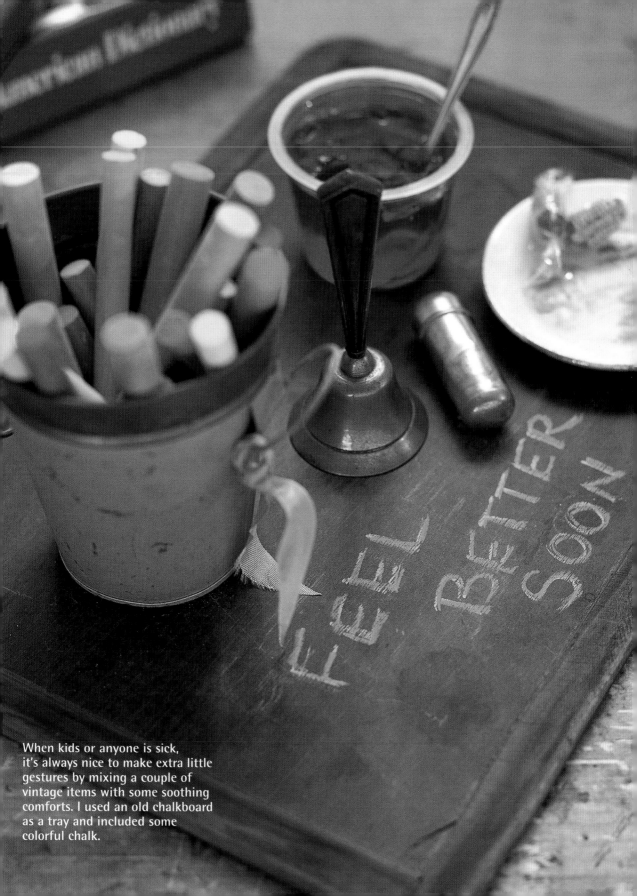

When kids or anyone is sick, it's always nice to make extra little gestures by mixing a couple of vintage items with some soothing comforts. I used an old chalkboard as a tray and included some colorful chalk.

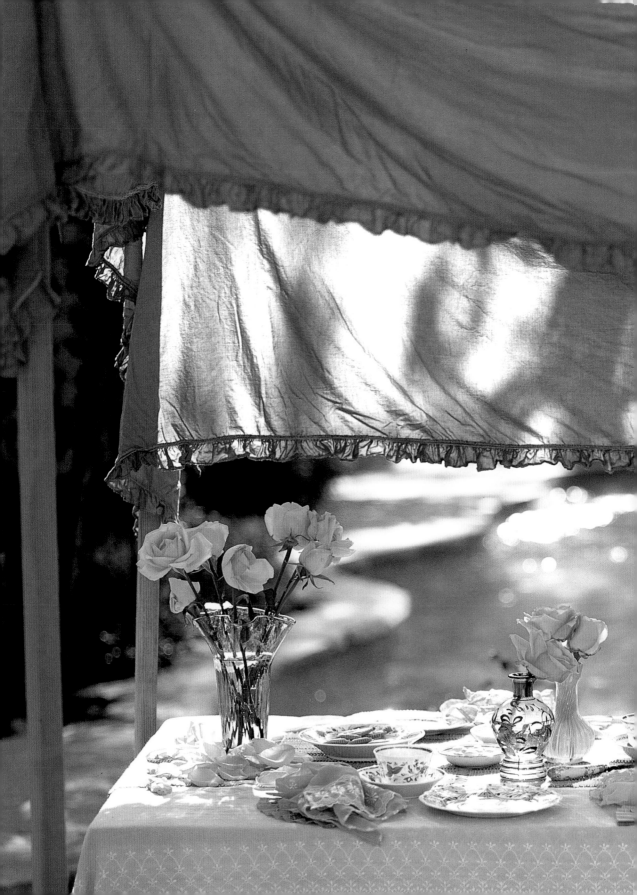

The Tent

Creating the perfect world
in which to entertain and give gifts

creating a wor

On occasion, I host various parties for friends and family. It's not always for a specific event: When the whim strikes me, I'll put together a party for no reason at all. I just think it's something nice to do. I approach entertaining as a gift to my guests. It's creating a whole world that's a gift. I've found that it's possible to fashion beautiful and unique settings quite inexpensively by committing to a few themes and using a combination of new and vintage elements, and other things I may find around my house. All it really takes is a little ingenuity. It can be quite simple, and the effects can be wonderful and diverse.

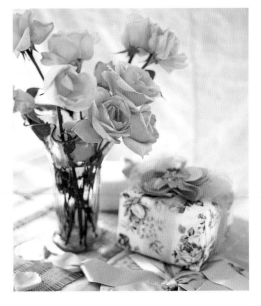

What's really important is to set the area, especially when working outside. Whether I'm working in a beautiful garden or even a patio, I create the stage by considering the location and thinking up ways to bring that into the setting. I always want the location to complement the setting, and vice versa.

Once, I decided to put together a lunch for a close friend's baby shower. I decided to stage it in my garden. Being surrounded by flowers and greenery is so life-affirming, which is what celebrating is all about. I decided that a tent of some kind might make it feel a bit more special. I envisioned something that felt somewhat temporary and rather breezy and lovely. The simplest solution was to put together my own idea of what the tent should be. The effort was minimal, and the effect was a lovely garden oasis, which became the main theme of the gathering.

Creating a whole world can be a gift in itself. I constructed this tent inexpensively and painlessly by placing seven-foot poles in four metal buckets filled with sand topped off with river rocks. I then draped a couple of lightweight tablecloths over the poles for a canopy effect.

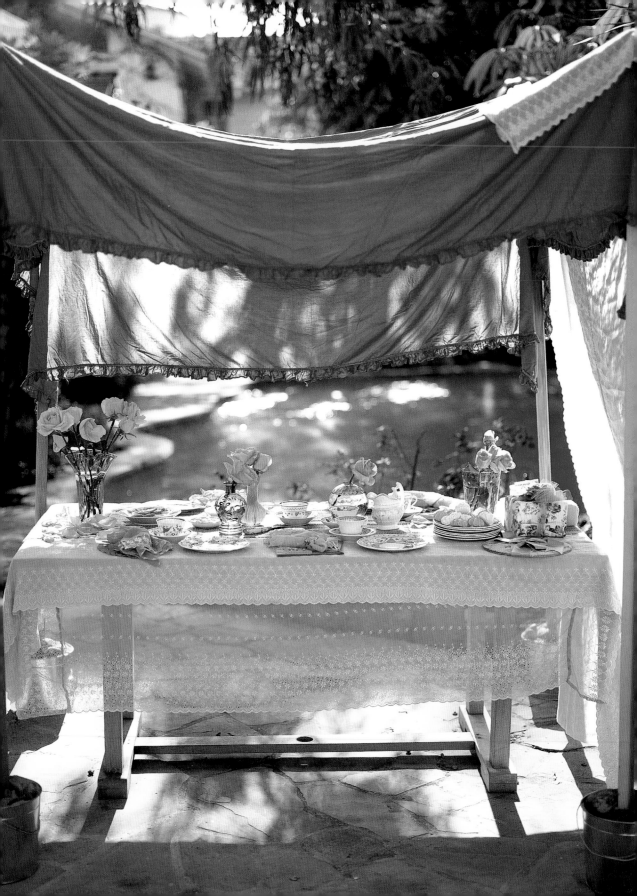

Showers

The notion of a baby shower stems from the tradition of bridal showers, which dates back centuries. It's a very sweet old story that's said to have happened in Holland.

The story goes that a young woman and a bighearted but poor miller fell in love and decided to marry. The young woman's father was angry over his daughter's choice of husband and refused the couple her dowry. At that time, a dowry was mainly the essentials for setting up a house together: pots, pans, dishes, linens, those types of things. The miller could not provide much in the way of household goods, because over the years he had given away all his possessions to people less fortunate than himself. The situation seemed hopeless. Then the townspeople, all the people the miller had helped over the years, banded together and each gave the couple a household item that they could spare. After everything was said and done, the young woman and the miller had everything they needed. They married, and are believed to have lived happily ever after.

It's fairly easy to see why the concept of a shower lent itself so easily to the birth of a baby. It's another new beginning for which a great deal of supplies are needed.

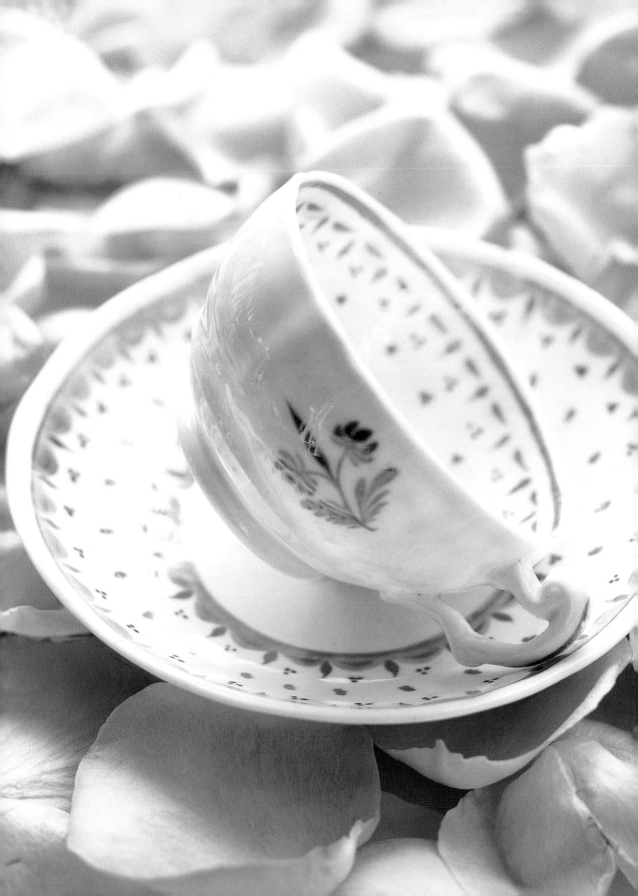

Table Setting

Even though the table was in the middle of a garden, I wanted to make it seem special by holding true to the traditions of a formal table. I always apply my own Shabby Chic principles to tradition, but nonetheless, I stayed with the basic ideas of a formal table. To me, this is all about using a tablecloth, real china, sterling utensils, cloth napkins, and flower arrangements.

Because I tend to focus on color, I wanted the tableware to work with the tent and in the garden. Lustreware seemed the perfect fit to me. The colors worked within the palette and the little flowers and designs on the plates and teacups seemed reminiscent of a garden. I think its shiny quality lends itself to festivity and is so feminine.

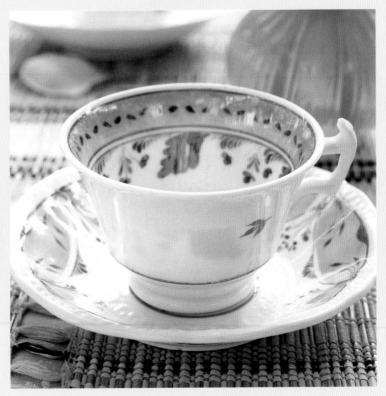

Opposite: Right now, this is my favorite cup in the whole world. It's at least one hundred years old.

Lustreware

The roots of lustreware date back centuries,
originally to the Middle East. The shimmer came
from glazing pottery with real bits of metal.
In the nineteenth century, English potters and
china makers began working with the process,
but took it a step further by creating less earthy
colors and experimenting with more delicate
patterns. It was still, however, a tedious process
that was done by hand. It was applied mainly to tea
sets, so those are the most common examples to
come across. However, it is possible to find larger
English Lustre pieces. It's best to store Lustreware
out of direct sunlight to preserve the glaze.

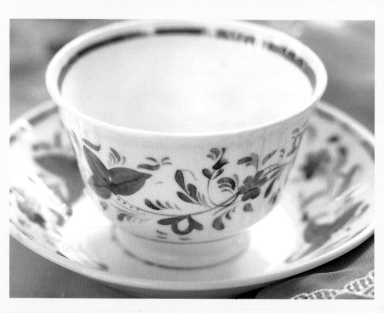

set the mood

When designing a whole world, it's important to determine the feeling that you want to create. Then it's just a matter of thinking in terms of solutions. How do I set the mood? What are the elements I need? How do I go about realizing them? Half the fun is in the challenge of dreaming up the world, and the other half is in creating it.

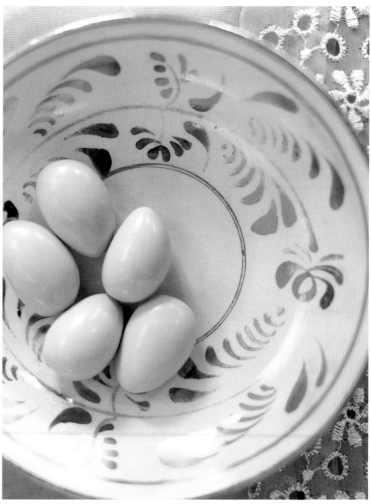

Opposite: This pale, gentle little creamer sits quietly on a bed of rose petals. It's a sweet touch.

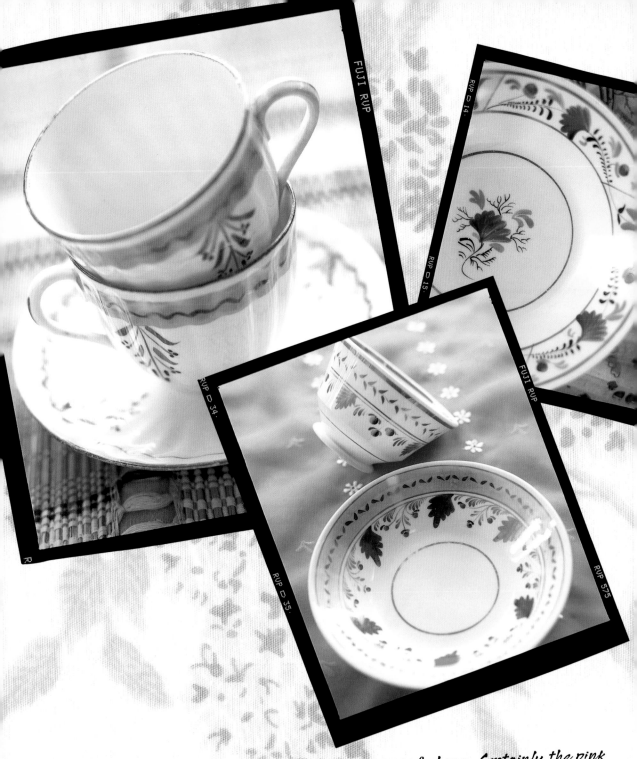

Lustreware is probably one of my favorite types of china. Certainly the pink that was so commonly used makes for a feminine theme, but the irregularities and imperfections somehow tone down what could be seen as too sweet.

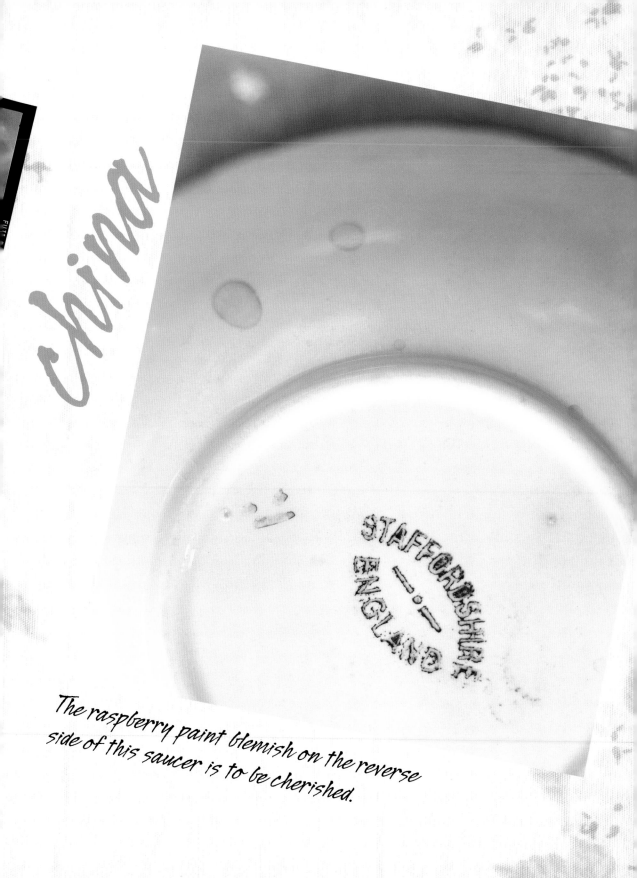

china

STAFFORDSHIRE
ENGLAND

The raspberry paint blemish on the reverse
side of this saucer is to be cherished.

As is the Shabby Chic way, the fact that nothing truly matches is absolutely fine. In fact, it gives the whole scene a bit more ambience. The result is full of character and an example of how you can use bits and bobs from around the house and put them together to make a beautiful stage.

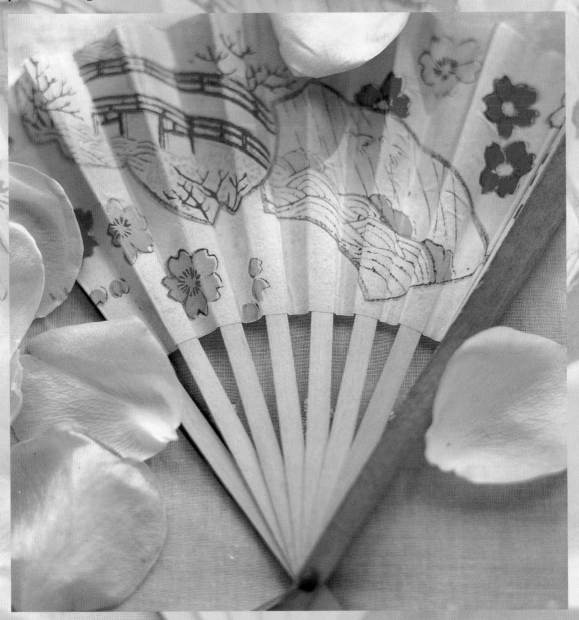

Layering on a table is nice to do, so along with the Indian saris as my base, I added some lovely hand-painted fans on which the napkins could rest.

A sparkly old belt buckle served as a fancy napkin ring.

Staying within the concept of committing to a theme, I chose a selection of sari fabric scraps and made some mix-and-match napkins. The fabric is so fine that I bunched a couple together. A child's bracelet is an original thought for a napkin ring.

Choosing a few cliché but perfect food accessories helps tell the story. These meringues were a must-have as I was wandering the bakery isle in a supermarket.

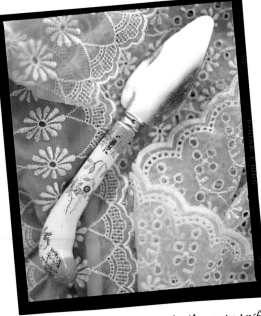

With its gentle porcelain handle, this cake knife asked to be included in the party.

No table would be complete for me without flowers. For my oasis, because there was so much color going on everywhere, I decided to use only one type of flower . . . pink roses. I wanted to keep it simple, but still make it feel rich.

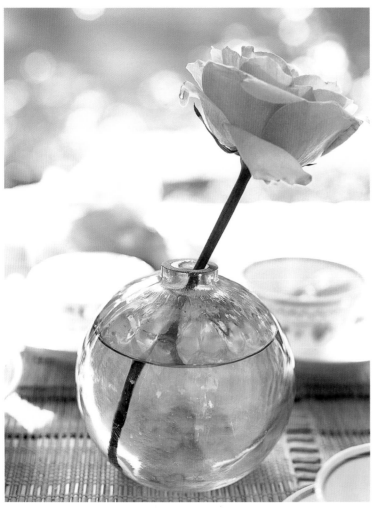

This simple round turquoise vase is just lovely.

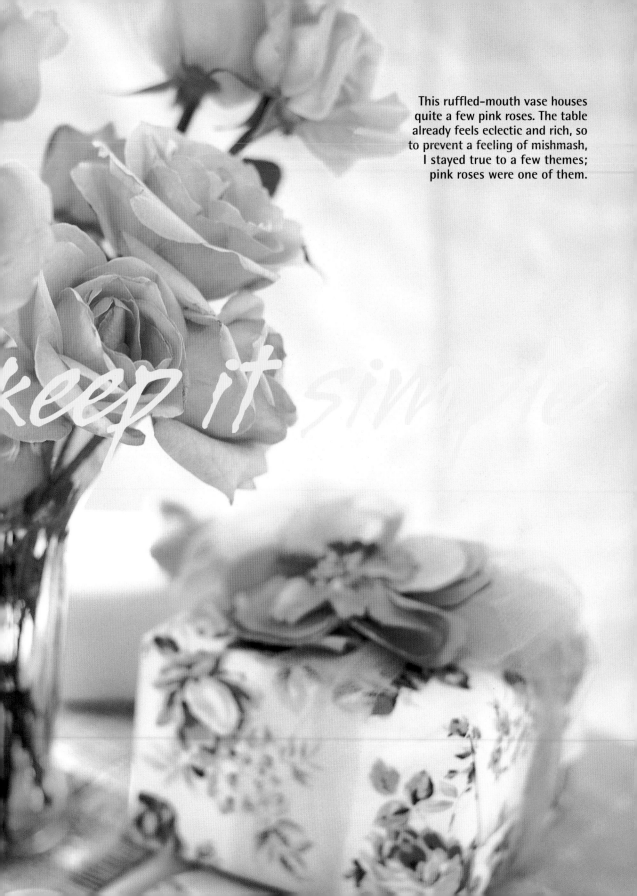

This ruffled–mouth vase houses quite a few pink roses. The table already feels eclectic and rich, so to prevent a feeling of mishmash, I stayed true to a few themes; pink roses were one of them.

keep it simple

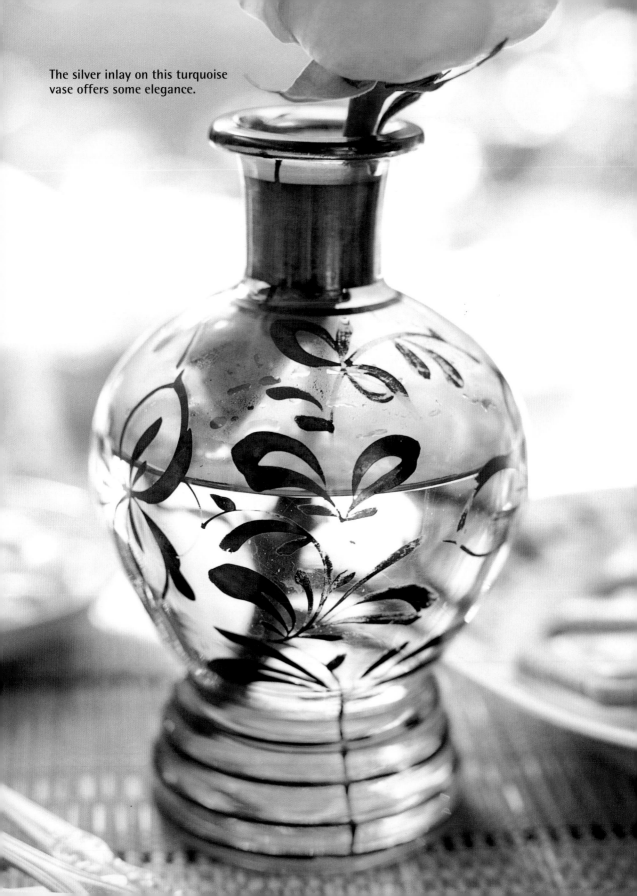

The silver inlay on this turquoise
vase offers some elegance.

This teeny-weeny little vase only cost a few pennies. Standing alone it said very little, but added to the turquoise collection, it stands tall.

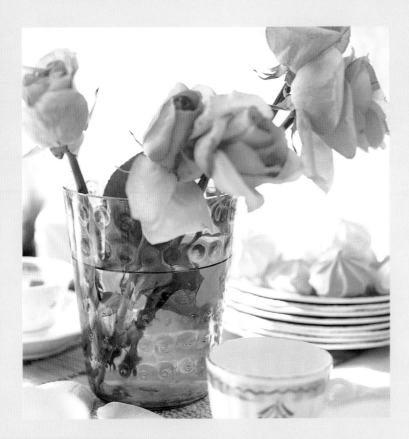

I'm always on the lookout for glassware to include in my palette. While this turquoise vase may be a little strong in color, as an accent I love it. The dimples on this vase feel watery and fun, perhaps a little contemporary, but nothing a floppy rose can't mellow down.

Party Favors

I tried to think through every detail. I spent a lot of time contemplating the party favors. I focused on the favors being a continuation of the theme. I wanted them to be a tangible reminder of the party for each person, and I also wanted the favors to be meaningful. So I decided upon herb plants in simple pink baskets. Herbs continued the feel of the garden, but more so carried significance relevant to each guest because of their meanings. I matched the meaning of the herbs with the characters of each of my guests. Of course, the same gesture could be made with fresh or vintage flowers. Like herbs, they too possess meanings. (I've included a list of my favorite flowers and their meanings in the Buds, Blossoms, and Blooms chapter.) I always pay close attention to these types of details. No matter how minor they might seem, they really help to create a very personal feeling.

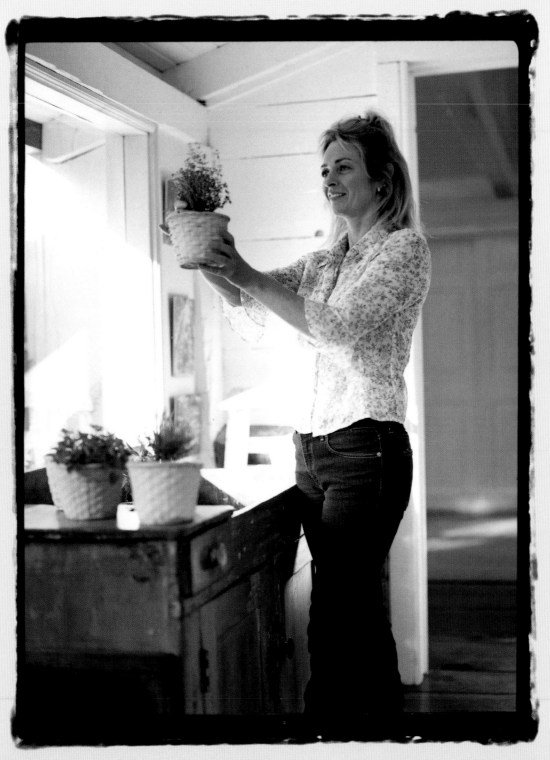

All the guests at this party will take home a potted herb plant. I chose an herb with a relevant meaning for each guest. What fun it was for me to pop the herbs in lovely pink wicker pots and contemplate who should get which one.

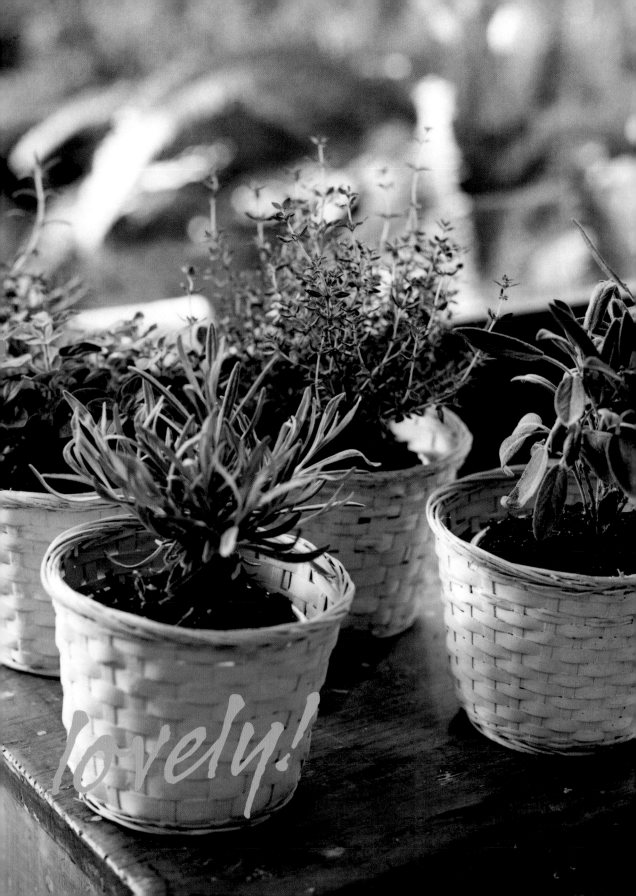

Herbs

In addition to being lovely and useful, herbs have meanings behind them. The meaning of rosemary, for example, is "remembrance." A small potted rosemary plant makes a significant statement when given as a gift once the meaning is taken into consideration. It could make a great party favor for a guest to remember the party, or it might be a sweet going-away gift for someone to remember the people left behind. I think herbs make lovely and very meaningful gifts. There seems to be an herb evocative of virtually any sentiment I would want to relate.

THYME

ROSEMARY

CHAMOMILE

Chamomile	*Patience*
Basil	*Good wishes*
Lavender	*Devotion*
Marjoram	*Joy*
Mint	*Prosperity*
Oregano	*Happiness*
Parsley	*Festivity*
Rosemary	*Remembrance*
Thyme	*Courage*

LAVENDER

OREGANO

Resources

Elements featured in this book have been compiled from these stores.

RAJIV KAPOOR

TARUN ARORA

India Sweets & Spices

(Established since 1985)

PH : (310) 837-5286

9409 VENICE BL.
CULVER CITY, CA 90230

www.indiasweetsandspices.com

About Antiques

Jackie & Lorraine
(818) 249-8587

3533 Oceanview Blvd.
Glendale, CA 91208
Wed - Sat 11- 5

MÉLANGE

Eclectic selection of Fine Antiques,
Estate Jewelry, Paintings & Textiles
949-497-4915
Kathleen Robertson
1235 N. Coast Hwy. Laguna Beach, CA 92651

Rachel Ashwell founded the Shabby Chic style in 1989 and is now the host of *Rachel Ashwell's Shabby Chic* on the Style network. She is the author of the bestselling *Shabby Chic*, *Rachel Ashwell's Shabby Chic Treasure Hunting and Decorating Guide*, and *The Shabby Chic Home*. She lives in Malibu, California.

Amy Neunsinger is a freelance photographer who lives in Los Angeles and New York City.

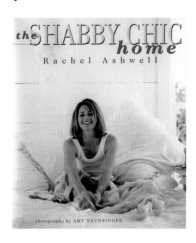
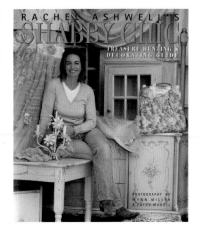